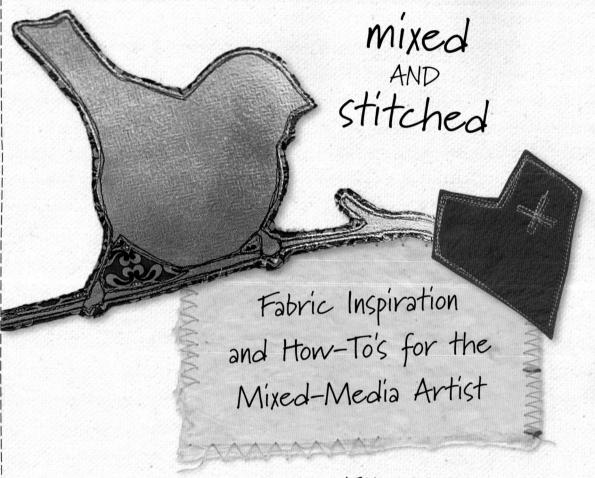

# mixed
## AND
# stitched

## Fabric Inspiration and How-To's for the Mixed-Media Artist

### JEN OSBORN

15  14  13  12  11    5  4  3  2  1

Distributed in Canada by Fraser Direct
100 Armstrong Avenue
Georgetown, ON, Canada  L7G 5S4
Tel: (905) 877-4411

www.fwmedia.com

Distributed in the U.K. and Europe by F&W Media International
Brunel House, Newton Abbot, Devon, TQ12 4PU, England
Tel: (+44) 1626 323200, Fax: (+44) 1626 323319
Email: enquiries@fwmedia.com

Distributed in Australia by Capricorn Link
P.O. Box 704, S. Windsor, NSW 2756 Australia
Tel: (02) 4577-3555

Library of Congress Cataloging-in-Publication Data
Osborn, Jen
  Mixed and stitched : fabric inspiration and how-to's for the mixed-media artist / Jen Osborn.
    p. cm.
  Includes index.
  ISBN-13: 978-1-4403-0837-6 (pbk. : alk. paper)
  ISBN-10: 1-4403-0837-3 (pbk. : alk. paper)
  1. Textile crafts. 2. Color in textile crafts. 3. Dyes and dyeing. 4. Mixed media textiles. I. Title.
  TT699.O83 2011
  746--dc22
                    2010045515

EDITOR: Kelly Biscopink

DESIGNER: Julie Barnett

PRODUCTION COORDINATOR: Greg Nock

PHOTOGRAPHERS: Christine Polomsky, Al Parrish (unless otherwise noted)

PHOTO STYLIST: Jan Nickum

# DEDICATIONS AND ACKNOWLEDGMENTS

This book is dedicated to anyone who's ever been told they're doing it wrong—you're not!

*When the student is ready, the teacher will appear.*
— Buddhist Proverb

I read this phrase recently, and couldn't believe the timing. For the past couple of years it seems as if I'm afloat on a sea of synchronicity. Fate seems to be bonking me on the head with amazing people, which in turn has led to wonderful opportunities. One of those opportunities was the chance to write this book. It's been a long and twisted road from the place where I daydreamed about writing it to actually putting these words down on paper. I have to confess that this isn't the book I set out to write, but I've found that writing is about growing, and it's grown into something all its own. I'm immensely proud of *Mixed and Stitched*, and have wholeheartedly enjoyed the entire creative process. It's taught me volumes about who I am, how I create, and where I want to go from here. My exploration into the world of fabric has been more wonderful than my wildest dreams could have imagined, and has brought me to friends and mentors without whom I could not have done this. Thank you for believing in me...especially before I knew how to believe in myself!

I offer a special thank you to my family, and all of the amazing women who have mentored me along the way. You opened up your creative souls to me, and kept me on the path that led to this book. That means you Grandma Lois, MOM, Sarah Fishburn, Anna Barrow, Bernie Berlin, Jenny Doh and Vicki Strause! I wouldn't be here if you hadn't shared everything you knew about art, creating, and life with me. I'm constantly amazed and inspired by all you do in art as well as life.

Thank you to all the staff at F+W who stayed with me even when it looked like I was trying to shrink into the woodwork and disappear. Thank you to Tonia Davenport for spending months working on my proposal with me so that it had no chance of being turned down. Thank you to Christine Polomsky for your keen photographic eye, and for making Jules her nest. Thank you to the marketing department for making me feel like I knew what I was talking about and for helping me sell this book. Most of all, thank you to my editor, Kelly Biscopink, for keeping me writing when I thought I wasn't going to make it, and helping me write my first book. I cannot thank you enough for all your hard work!

Thank you to all my art peeps out there who keep me afloat with your phone calls, encouraging e-mails, comments, feedback and constant desire for more. A special thank you to Lori, Catherine and Cathy; your phone calls and love made all the difference in the world! I love sharing my art with you, and hope I never let you down!

Most of all, the biggest *thank you* in the world to my husband, Larry, and my two crazy teenagers, Jake and Jules. Some days I don't know why you put up with me. I'm sorry for the late nights, no food in the fridge, and empty closets. I love you three more than I can ever write here in words...but something tells me you already know that. Thank you for all the hugs, kisses, and endless laughter. You are my true heart and soul!

**syn·chro·nic·i·ty**

noun

the coincidental occurrence of events and esp. psychic events (as similar thoughts in widely separated persons or a mental image of an unexpected event before it happens) that seem related but are not explained by conventional mechanisms of causality

excerpt, *Merriam-Webster's Collegiate Dictionary*, 10th ed., s.v. "Synchronicity."

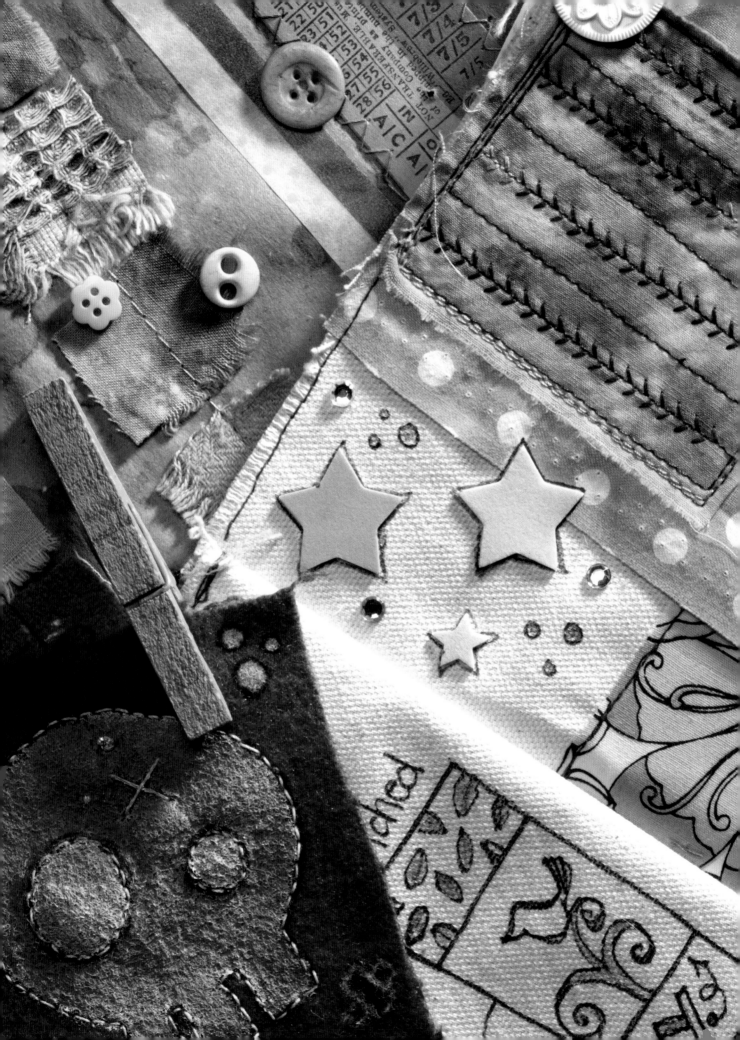

# ✳ contents

# introduction

**mix**

verb

- to combine or blend into one mass
- to combine with another
- to bring into close association

excerpt, *Merriam-Webster's Collegiate Dictionary*, 10th ed., s.v. "Mix."

You wanna know what I think? I think you can take all those rules everyone is always trying to shove down your throat about art—how it should be done, and all the ways you're doing it wrong— and toss them out the window of a speeding car. *No*, don't you dare look back to make sure they're not following you! Just press down on the gas pedal and go for it.

I've been teaching children and adults how to create wonderful things for the past ten years, and I can tell you that the thing I *always* teach first is that there is no right or wrong way to make art—there's just *your* way. That is one of the most important things I'd like you to understand before you read this book. I'm no better at making art than you are, and neither is anybody else. Creating something is a very personal thing, and I don't feel you should start off with someone telling you you're doing it all wrong. Nothing like someone breaking your legs and then telling you to run, eh?!

One of the questions I get asked most often is where my ideas come from. Honestly, I don't know. Sometimes they come from dreams I've had; sometimes they're sparked by a twig or piece of metal I see lying on the sidewalk; but most of the time they just seem to come pouring into my mind out of thin air. I do know that having inspiration all around me seems to help. So, I've poured my ideas and some of the ways I light my creative spark into this book in the hopes that it will inspire you to live a more creative life.

It's a proven fact that creating things with your hands calms the mind, heals the soul and helps us live a better life. I'm primarily a mixed-media artist, but sewing has brought a peace to me that I never dreamed possible in my racing, all-jumbled-up, discombobulated brain. I hope it will do the same for you, and that what you learn in this book turns out to be a gift you give yourself. Stitched art is a great way to express appreciation or to shower love on those around you. Plus, it can really make your house feel like a happy home to live in.

My mom tried to teach me how to sew many times throughout my life, but much to her chagrin, I was never really interested until recently. She is an awesome quilter, knitter, crafter and artist in her own right, and I should have jumped on the wagon early on. Since I opened myself up to what she had to teach me about sewing, I've met many other sewers who have inspired me to get better. I've learned so much that there are times I'm sure I don't remember half of it, and that's okay.

The wonderful thing about sewing is that fabric is forgiving, and most of the time you can just pick out your errant stitches or cut off what you've messed up and try again. When I embarked on my expedition into the world of mixed-media art almost a decade ago, my goal was to learn as much as possible. I've read books, trolled blogs late into the night, gone to huge teaching events, and simply listened to the ladies at my local quilt shop. I've found that the most helpful thing I've done is simply *trying*, whether I fully understood how to do it or not. There's a lot to be said for rolling up your sleeves and diving into the unknown.

I encourage you to take what I share with you in this book and use it as a spring board for your own journey into the world of mixed-media and stitching. My hope is that, at its best, this book will inspire you to dive deep into the world of fabric, teach you how to dye your own creations, and make you want to stitch up wonderful and amazing things. At its worst, I hope it at least gives you a good chuckle and a bright bonfire. {wink!}

Stitching and making art runs deep in my soul, and it's such a dream to share everything I've learned so far with all of you. Thank you!

*now go make art!*

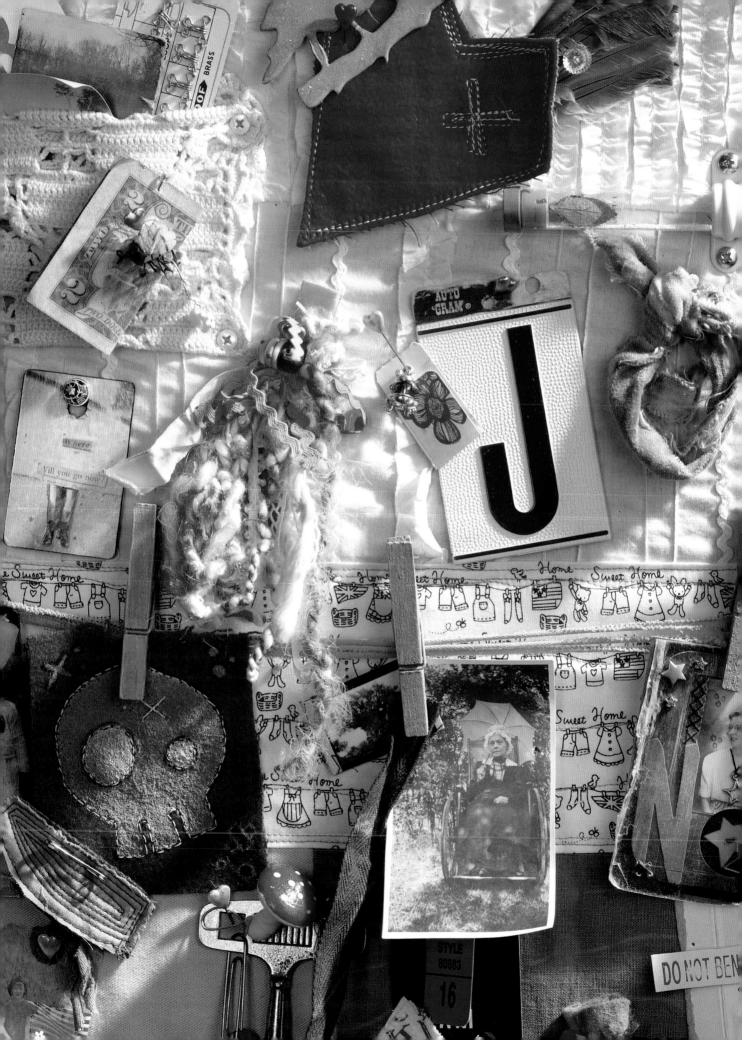

# forget-the-rules techniques

**1**

In the following chapter, I'm going to teach you what I learned about dyeing and stitching when I tossed out all those pesky rules, and began experimenting with abandon on my own.

I love to combine dye pigments to create my own colors; I'll show you how to do this in your own kitchen so you can set off into the universe of dye alchemy. Then we'll get lost in the stitches as I tell you all my sewing tricks and tips.

I'm by no means an expert on anything, and I believe that there's always more out there to learn. I've learned so much from those who have so generously shared their art with me, and I dedicate this chapter to all those amazing artists. Thank you for teaching me everything you know and encouraging me to pass it on. It's in that spirit that I open up my noggin and let you take a peek at what's inside!

**al•che•my**

noun

• a medieval chemical science and speculative philosophy aiming to achieve the transmutation of the base metals into gold, the discovery of a universal cure for disease, and the discovery of a means of indefinitely prolonging life

• a power or process of transforming something common into something special

excerpt, *Merriam-Webster's Collegiate Dictionary*, 10th ed., s.v. "Alchemy."

# Before You Begin...

I didn't stumble off blindly into dyeing fabric, and I don't believe that you should have to either. To that end, I'll gladly tell you everything I've discovered on my adventures into dye alchemy. I don't claim to be any sort of expert—quite the contrary. I will be a student of dye techniques for the rest of my life, but I don't believe you have to be an expert to share found knowledge. I started dyeing with a little advice from a friend and the basic directions on a box of powder dye, and I experimented from there. I've dyed and tie-dyed many times up to this point in my life, but never this often or on such a grand scale. I have used both liquid and powder dyes of any brand I could get my hands on, and I have nothing negative to say about any of them. For the past couple of years though, I've been experimenting with iDye for natural fibers—I love the texture of natural fibers and tend to have way more cotton, wool and silk to play with, so that's what I'll be covering in the following pages.

I'm a scientist at heart, so it just seemed logical to start performing dye experiments by mixing the powders together. I didn't use a color wheel—I only used what I had in my brain from my days of watercolor paints and coloring books. I simply mixed together any colors that I knew wouldn't turn into *mud*. That means no mixing oranges or reds with greens unless you're purposely going for brown. Otherwise, the sky's the limit!

You're also not limited to working only with primary colors. Powdered dyes come in a rainbow of choices now, and that means you can really tweak your custom colors to the exact hue and shade you're shooting for. I made some beautiful lilacs by mixing pinks, blues and reds of various shades.

The best advice I can give you is to be open to the unexpected and to experiment like crazy. Some of my most amazing colors and patterns came from just giving it a go, no questions knocking around in my brain to slow me down. Now's the time to jump in feet first and experiment away! I'd love to hear all about your adventures in dye via e-mail or over on the *Mixed and Stitched* blog (mixedandstitched.blogspot.com). Please come share all your discoveries and inspire us all on to greater heights!

# Safety

One of the most important things to always remember, and the one rule never to be broken, is that once you use a supply or utensil for dyeing, it is *not* to be used for food or food preparation ever again!

You don't even want to risk mixing your dye supplies in with food utensils by throwing them together in the dishwasher. Wash all of your dye supplies in the sink, and then store them inside your dye pot to keep them separated from kitchen supplies. Make sure to clean all the dye out of your sink by rinsing the sink thoroughly with hot water and a cleanser like Lysol or bleach. Don't panic if you spill the dye powder or liquid mix on your stove or countertop. You can use a spray bleach to clean up any mess you make.

Everything is up to experimentation except your safety and that of your family.

 notion

A natural fiber is one that comes from a plant or animal, and is not synthetic. Cotton, silk and wool are great examples of natural fibers, while polyester and nylon are synthetic.

# Setting Up Your Space

Dyeing with powder is a messy endeavor, so we're going to start off by protecting your kitchen, your good clothes and your hands.

I have a pair of jeans and a T-shirt that are dedicated to messy art-making. They're the clothes I paint in, and they are perfect for days when I feel like mixing up dye. I wear rubber kitchen gloves to protect my hands from the heat, but you'll probably want to wear rubber medical gloves like they sell in the paint section of the hardware store. If you choose not to wear them, I'll warn you that your hands will be *very* colorful for the next week or so. You will definitely need thick rubber kitchen/cleaning gloves to protect your hands from the hot dye bath when you first put fabric in the pot and later to rinse out the hot, dyed fabric.

Tear off a section of brown postal/craft wrap that is large enough to cover the counter adjacent to the burner you'll be dyeing on. Use masking tape along the top and bottom edges to hold it to the counter so it doesn't slip off at an inconvenient time. I like to place the paper curved side down, and wrap the curve around and under the edge of my countertop so I don't smear dye on the underside while I'm experimenting. Cover any counter you'll be setting things down on, moving dye utensils over, or are in danger of splashing. The dye will color your countertop, and shouldn't be ingested by accidental contamination and forgetfulness.

One of the great things about this dye method is that you only need a few simple utensils and you're on your way. You'll need a wooden spoon to stir up your dye pot, and a few very small measuring spoons to scoop out your dye powder for mixing. I have a "smidgen/dash/pinch" set my family bought me for Christmas one year, but a standard measuring set will do just fine. If you want a little more control moving your fabric around, you can use a pair of tongs.

You will also need a large boiling pot for mixing your dye bath. I recommend getting one with non-stick coating because the coating will help you to wipe out the excess dye during cleaning. Look around at your local thrift stores to find a dye pot—you should be able to find an inexpensive one. Depending on the size pot you have, each dye bath can saturate about 2–3 pounds (0.9–1.4 kgs) of fabric.

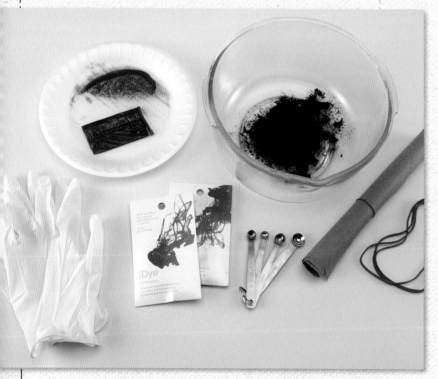

## bare necessities:

- ✿ brown postal/craft wrap
- ✿ dryer or clothesline
- ✿ large stove-top pot (nonstick coating recommended)
- ✿ large rubber bands
- ✿ liquid bleach and bleach pen
- ✿ masking tape
- ✿ paper towels
- ✿ permanent pen
- ✿ powdered dye
- ✿ rubber cleaning/medical gloves
- ✿ sink
- ✿ small measuring spoons
- ✿ stove
- ✿ 2–3 pounds (0.9–1.4 kgs) of fabrics and ribbons
- ✿ washing machine
- ✿ wooden spoon/paint stir stick

*Note: I've used a glass mixing bowl for the photography in the book so you can see what I'm doing, but make sure that you are making your dye bath in a metal, stove-top pot.*

# Grab Your Fabric

One of the coolest accidental discoveries I made while dyeing is that all material does not dye the same shade. If you put fifteen different types of fabric into one dye pot, you are going to end up with fifteen variations in your dye lot, each one slightly different from the next.

Sometimes, you even get big shockers. One of the most memorable examples of this is when I was mixing up my first batch of dark blue. I had one piece of fabric turn out a bright sky blue and another piece pitch black. I couldn't believe my eyes as I pulled each piece from my dryer. Imagine my delight when I realized the color possibilities available to me by simply varying my choice of fabrics! My *Dye Recipe Book* project on page 42 is a great way of recording which fabrics came from which dye lot, in case you ever want to recreate the same color.

Choosing the types of fabrics to dye is one of the areas where I slow down and take time to think about what I'm doing. Keep in mind that there is only so much space in the dye pot, so maximize the variation you get by choosing your materials and amounts carefully.

You're not just limited to white fabric when it comes to material choice either. You can dye anything light enough to show a color change—off-white, cream, tan, pink, light blue and yellow are all good choices. By dyeing a variety of colors, you are ensuring great end results.

You're also not limited to fabric made from plants, like cotton. Remember that I said this dye can be used on any natural fibers? This means you can experiment with unusual materials like leather, fur, yarn, silkworm eggs or rods, and anything else that grows or comes from a living creature. There are seven common types of natural textiles that you will be able to find easily: silk, cotton, linen, hemp, wool and bamboo.

All of these materials are also fantastic choices for your dye experiments because each has its own unique texture. Canvas, duck cloth, linen and a coarsely woven fabric called monk's cloth are really fun textures to experiment with. Don't get caught up

## notion

Remember how I told you that you have to have special dye for polyester fabrics? This can be used to your advantage. Some textured fabrics are sewn with polyester thread which means that the fabric will dye, but the thread won't, leaving a cool visual pattern behind.

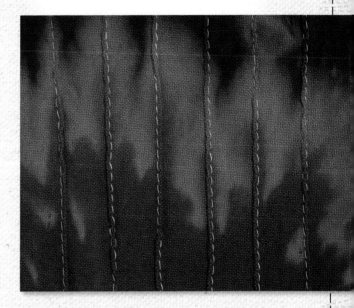

in choosing only medium to rough textured materials, either. You'll get some fantastic results from softer materials like cashmere, angora, bamboo batting and even threadbare antique linens. Sheer fabrics can be dyed and layered with more opaque fabrics to create even more color variation.

Let your imagination run wild, and let your fingertips do the choosing for you. Try closing your eyes and running your fingers blindly through the remnant bin and select the materials that feel different and unique!

# Stove-Top Alchemy

Now that you've chosen your fabrics, it's time to start having some fun. Fill your dye pot up with water until it's about 2 inches (5cms) from the rim, and place it on one of your burners over medium-high heat. While the water is heating up, you can begin choosing your dye colors. I mostly work with the iDye brand of dyes, but you should get similar results from most dry pigment dyes.

In general, one main color will be your base and will require the most pigment powder. Begin with a color that is close to the color you are trying to create. You will use small amounts of a secondary color to alter your base color until you are satisfied. For example: If you want to make a yellow-orange color, start with a yellow base and add small amounts of red or orange.

Your base color should almost always be the lightest color in your mix. It takes much less of a darker pigment to change a lighter one than vice versa. Remember this when you are experimenting with mixing so you don't make your dye too dark; you'll waste a ton of lighter pigment trying to get the proper color. If that happens, and it probably will at least once, you can chalk it up to a lesson learned. Remember, too, that you don't need to add a million different pigments to end up with a fabulous color. You can get a lot of variety by using only three or four colors, and simply changing the amount of pigment you add into your base.

## notion

A free alternative to a wooden spoon is to use the wooden paint stir sticks from the hardware store. This allows you to have a stick for every color family, and helps you tell what color you're mixing up in your dye pot.

To begin mixing your dye, add $^1/_2$ to $^3/_4$ of your base color powder packet to the warm water, stirring as you go with a wooden spoon or paint stir stick. Heat your water to a simmer, continuing to stir and mix in the base color as the water heats. When your water/dye concoction begins to steam, begin adding in your other pigments using the small measuring spoons. Add in these other colors a little bit at a time—it's very easy to overdo it and ruin the whole mix.

Use a notepad to keep track of how much pigment of each color you are adding. This will come in handy later to make your own *Dye Recipe Book* (page 42). When I first started dyeing my own fabric, I didn't do this and I really wish I would have documented some of my earlier experiments. Since then, I've written down all my recipes so that I can go back and remix my favorite colors over and over again. You probably won't be able to get the exact same result each time, but you'll get pretty close. Because powder dyes are a combination of pigments, you may have a slight variation in dye lot even when following your own recipe exactly. It's one of those things you're just going to have to let go of and live with.

## notion

Some powdered dyes, like iDye, come in cellulose packets that dissolve in hot water. However, if you're not using the whole dye packet, you can simply snip the corner off and carefully pour it into your dye pot or measuring spoon. Use transparent tape to close off the snipped corner and keep your open powder packet from spilling during storage. After you use up all the loose pigment in the packet, don't throw the packet away. There's still a lot of dye particles adhered to the inside. If your dye comes in cellulose packets, you can throw the entire packet into your water as one of your mix ins.

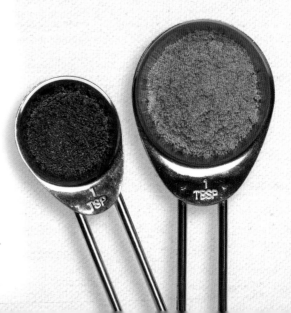

As you add in pigments, you're probably wondering how to tell what color you have in that pot of yours, aren't you? Well, it just so happens I have a nifty little trick for that problem! One of the best ways to gauge the color of your dye bath is by dipping in a scrap of plain white paper towel. Tear off a piece and dip the bottom edge into your dye bath. Watch as the paper wicks up the pigment-saturated water. This test will give you a pretty good idea of the true color, even after adding very small amounts of additional pigments. Here, you can see that I started out with a violet shade, but by adding a few spoonfuls of red I was able to darken the dye bath to a dusty lilac color.

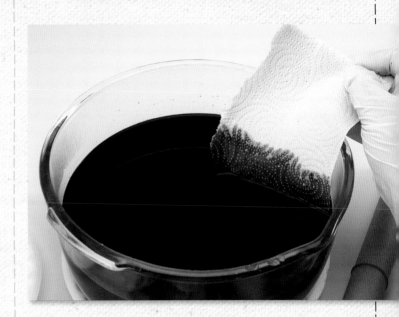

The paper towel testers can be just as luxurious as your fabric, so I always keep them to play with later. Scrunch them up to distribute the dye, open them up gently, and lay them out to air dry overnight. I like to use these small paper towel pieces in my *Dye Recipe Book* and many other mixed-media projects.

Once you successfully mix the color you're looking for, it's time to add in your fabric. Put on your rubber kitchen gloves and grab your pile of fabric. The dye package directions will tell you to wash your fabric first to remove the sizing and add it to the dye bath wet, but I ignore this step. One of the reasons for putting wet fabric into your dye bath is that it helps the pigment absorb evenly so you don't end up with splotchy fabric. Since we're trying to achieve a variegated look, we're going to break the rules and add our fabric in dry.

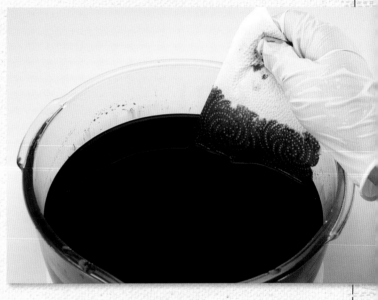

To get the most variety out of your dye lot, add both loose and bundled fabric (see page 18 for more information on bundling fabric). Loose pieces will be more evenly saturated, and bundled fabrics will be more mottled. Add in the fabric slowly so as not to overflow the pot and make a mess. If you go slow, you don't have to worry about the pot overflowing because the fabric will absorb the dye and equal out the difference. Slowly push all the fabric into the pot to make room for more until your pot is completely full.

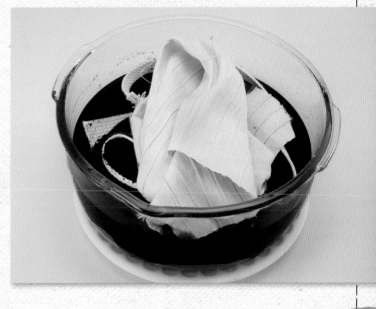

Make sure that you've added enough pigment to the water to dye the amount of fabric in your pile. The more fabric you use, the more pigment will be pulled out of the water, and the more of it you will need to add to dye all of your material. If you want to end up with a more splotchy, pigmented look to your fabric, don't mix your colors in thoroughly. Likewise, if you want the final result to be a more solid color, simply mix in your pigments thoroughly before adding fabric.

Keep stirring your loose and bundled fabric around in the pot as you bring the dye bath back up to a low boil. Once it comes up to a boil, immediately reduce it to a simmer. Set your kitchen timer for thirty minutes, and continue to stir the pot every seven minutes or so. When the timer goes off, turn off the burner, but leave the pot where it is. Set the timer for another thirty minutes, and go find something else to do while the fabric sits in the hot dye and cures.

After another thirty minutes has gone by, carefully move your pot to the sink, and start running cold water into your dye bath to begin cooling your fabric. Put on your rubber kitchen gloves so you don't burn yourself on the hot fabric. Keep in mind that even though the outside of your fabric bundles have cooled off, they are still smoking hot on the inside! Run cold water into your dye bath for a minute or so, and then dump out all the dye liquid, making sure not to pour any of your fabric down the drain.

Pull out the loose fabric and rinse it under the cold water, squeezing out the dye as you rinse. As you rinse out the fabric, pile it in the sink because it will continue to bleed and will still stain your countertops at this point. Keep this in mind, too, if you have a porcelain sink—you may want to use a washtub instead.

Once you have all the loose material out of the way, it's time to start on the bundles. Hold the rubber-banded bundles under the cold water, and give them a few good squeezes to push out the dye and pull in the fresh water. Then, slowly unwind the rubber bands from the outside of your bundles. Rinse the unbundled fabric pieces under the fresh cold water, just like you did with the loose pieces. It's going to take a little time and elbow grease to fully rinse all your fabric, but it will be worth it! Rinse everything until it runs almost clear before moving on to the next step.

Once you have all of your material fully rinsed, give your pot a good rinse out, and then put all of the fabric back in the pot to carry to your washing machine. You'll have a pretty good idea of what your finished material will look like at this point. It's going to be a little lighter in color after you give it a whirl in the washer and dryer, but you'll still get a good idea of where it's going. To finish up, throw the whole batch into your washing machine. Wash the fabric with detergent on a normal cycle with a warm water wash and a cold water rinse.

After giving it a bath, throw the fabric in your dryer with a fabric softener sheet to make it smell nice, and dry it on high heat until completely dry. You shouldn't have to worry about any more shrinkage in your fabric at this point because you've already heated it to boiling on the stovetop. The hot heat in the dryer helps to set your dye for good. Your dyed fabric should be fairly colorfast at this point, but I still wouldn't wash light fabrics with dark fabrics in future washings.

If you botched your dye mix and ended up with something dark and ominous, you have a couple of little tricks left up your sleeve to try and lighten it up. Instead of washing in warm water, set your washer to hot, which will rinse a little bit more dye out of your fabric and hopefully lighten it up enough to be salvageable. If it's still too dark, wash the fabric a third time on hot with a $1/3$ cup (78ml) of bleach.

Now it's time to ooh and ahh as you pull each piece from the dryer and gaze with pride at what you've done. Your fabric will be pretty wrinkly at this point, so give it a pass with a hot iron to smooth out the wrinkles and pretty it up.

All that's left is to clean up your mess, and go find new and exciting projects for the mountain of beautiful fabric you now own!

 notion

One thing to remember is that the fine particles of the powder fly around as you add them, and end up in unexpected places like your hood fan. After you've added all your fabric to the dye pot, take a minute to wipe all surfaces down with a wet rag, rinsing often. This will cut down on the mess you'll have to clean up when you're done.

COTTON LACE

WOOL FELT

QUILTED COTTON

WOVEN BAMBOO

MONK CLOTH

DAMASK

FLANNEL WITH RUBBER DOTS

BAMBOO BATTING

ONASBURG

COTTON BATTING

BAMBOO WAFFLE

FLANNEL

VINTAGE COTTON BEDSHEET

# Rubber Band Magic

I mentioned earlier in this section that you should add both loose fabric and bundled fabric to your dye bath. The loose fabric is a no-brainer, but let me explain a little more about the bundled variety. The easiest way to get a variegated look to your fabric is by wadding

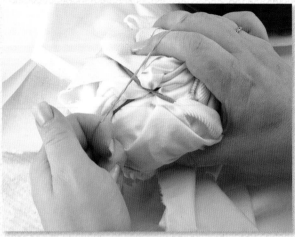

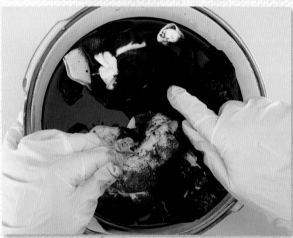

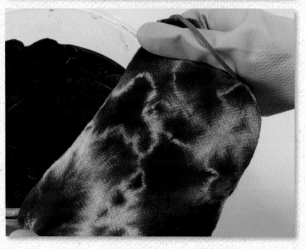

up the dry fabric, and wrapping it up in large rubber bands (like the ones left over from your Sunday paper). There's no specific way to do this—I just grab my fabric one piece at a time and wad it into a ball. Keep adding pieces of fabric until you have a wad about the size of a softball.

Hold the ball tight with one hand, and start wrapping one of the large rubber bands around it in a crisscross pattern. Wrap the rubber band around the middle one time, and then twist it just like you would to put a rubber band in your hair. Cross the rubber band at a forty-five degree angle to itself, and wrap it around a second time. Your wad of fabric should look somewhat like a birthday present at this point with the rubber band in a cross pattern.

Before you wrap the rubber band around one last time, tuck in any bits of fabric that are trying to escape so that the ball won't unravel when you submerge it into your dye bath.

When you add these bundled bits to your pot of dye, don't push them all the way under the dye surface like you did with the loose fabric pieces. Float your bundles near the surface so that the dry fabric starts wicking the dye mix into the center of your bundle. This will give you a really great tie-dyed effect that looks like lightning streaks, and will greatly vary the color of your dyed materials. Since the dye is slowly pulled from the outside of the bundle into the center, different pigments are absorbed into the fabric layers along the way.

Let these bundles float halfway beneath the surface for the first thirty minutes while still moving them around with your wooden spoon or paint stirrer. Submerge them fully for the last thirty minutes while everything cures, and follow the rest of the dye directions from *Stove-Top Alchemy* (pages 14–16).

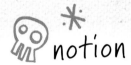 notion

Try experimenting with the way you bundle your fabric. Tie one bundle with a new fabric layer wrapped around each previous layer like a jawbreaker. Next, try mashing all the fabric together with no rhyme or reason. Each process will yield a different design pattern.

# Bleach Spots

Household bleach is another tool in your dye arsenal for getting the widest variety of shades from one dye pot. There are a few different ways to use bleach, so experiment and have fun! The first and simplest bleach method is to add bleach into the washing machine when you wash your fabric for the first time after dyeing. Pour approximately ⅓ cup (78ml) of bleach into the water after the washer has filled up and is ready to agitate for the first time. Then add the fabric to your bleach rinse, and wash. You only need a little bit of bleach to lighten up your fabric color, so try experimenting with different amounts and see what you like.

The second bleach method is to splash liquid bleach onto your rinsed, dyed fabric before you toss it in the washing machine. First, spread the wet fabric out on the sidewalk or driveway. Then use a spoon to splash the bleach onto the wet fabric, or squirt

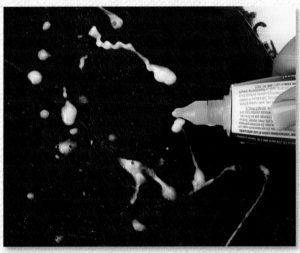

the fabric with bleach from a spray bottle. You have to work fast because the bleach continues to work as you move from piece to piece, and it can bleach too much of the color from your fabric if left too long. I keep a five gallon bucket of water on hand when I do this, and quickly dunk each piece into the fresh water immediately after pouring the bleach on it. This won't stop the bleach from working completely, but it greatly slows down the process. Keep in mind that you're adding bleach to the water every time you dunk, and eventually you're going to have too much bleach in the water to rinse out your fabric.

After splashing your fabric with bleach and rinsing, wash like the nonbleached fabric. *Do not* wash bleached and unbleached fabric together, or you will bleach all of your fabric. This can be a fun trick to do on purpose, but heartbreaking to do by accident, especially if you had one or two pieces that you were in love with.

You can also do a lot of fun things with one of those nifty little bleach pens. Try giving the pen a big squeeze and splatter your fabric (the thicker pen bleach won't splatter as wildly as liquid bleach). You can also use the bleach pen to draw words or shapes on your dyed fabric to simulate the look of wax batik. You'll get a more subtle effect with the bleach pens than you will with the liquid because it doesn't spread out into the fabric.

Your imagination is the only limit to what you can achieve with this little trick so let it run wild!

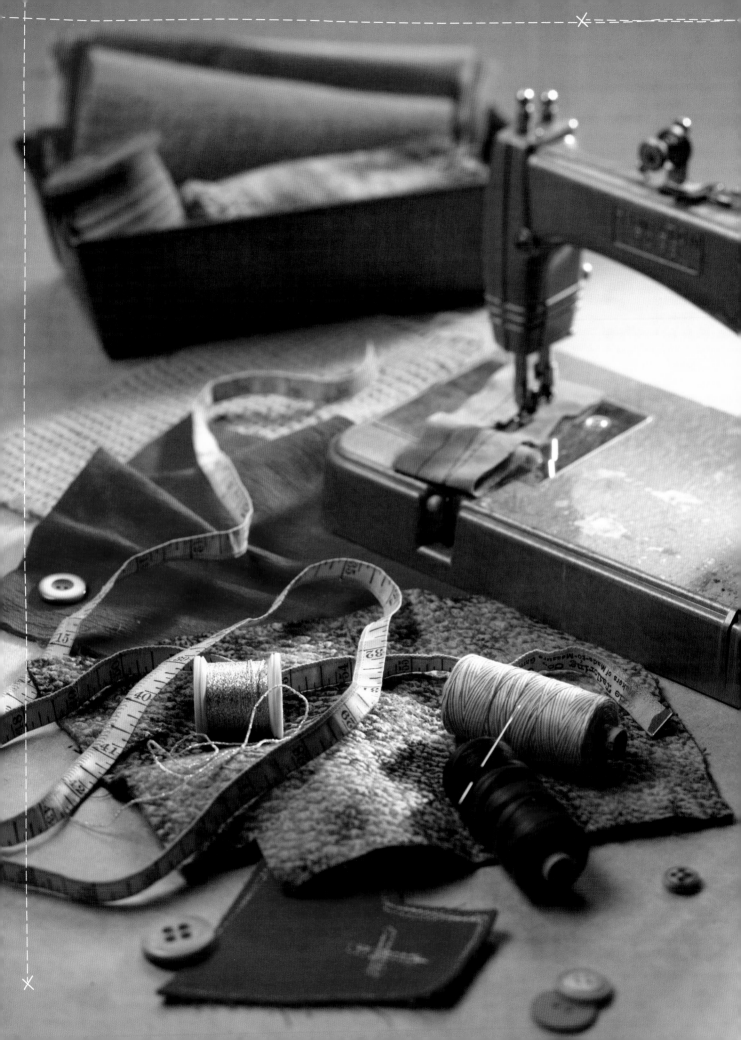

## Before You Begin...

Okay, so you've made this ginormous mountain of dyed and altered fabric, and are now wondering what you're supposed to do with all of it, right? Sew and stitch it up into amazing home goods for yourself or those you love, that's what!

Sewing can be meditative and incredibly rewarding if you can learn to relax and go with the flow, but it is one of those strange hobbies that really seem to intimidate people, myself included. I had a light bulb moment as I helped my daughter rekindle her love of sewing when we made a quilted pouch together. Every step of the way, she would look up at me in frustration over the lack of evenness in her stitches. My response was that sewing from the heart is an imperfect task—we all have the same problems, even those of us who have been sewing for years. Sewing is one of those things that you get better at with practice, but ultimately must learn to accept imperfection as a fact of sewing. It's a hard pill to swallow, and many of us give up our sewing hobby early on due to frustration.

When I became a mixed-media artist, I started sewing papers together to add texture to my artwork. That slowly evolved into sewing fabric together to create heartfelt home goods for others. Every time I sent something off for an exchange, I would worry that it wasn't good enough or that I'd done something *the wrong way*. But every time, the recipient thanked me for sending something that had been so obviously sewn with love.

So, with that in mind, I'd like you to promise me the following: If you are new to sewing, you'll take it easy on yourself and just have a good time learning the basics. Likewise, if you've been sewing for any length of time, please cut yourself some slack and enjoy the process of creation without the expectation of perfection looming over your head.

One of the things I've grown to love about hand-made items is the fact that they *look* handmade and not factory produced. Part of what gives handmade items their charm and endears them to our hearts are the little imperfections that give away the fact that they've been made by hands and hearts of love.

## Sewing Machine Basics

Before we start sewing on fabric, let's go over a few of the basics.

**NUMBER 1: MAINTENANCE**

Keep your sewing machine clean and oiled. The bobbin casing and motor gather lint and thread bits as you sew. If your machine has been sitting unused in your basement or attic, I would highly suggest you take it to a sewing machine repair shop and have it serviced. This is generally a very inexpensive procedure that can end up costing next to nothing if you find a coupon in your local paper. I'm by no means a stickler for keeping my machine oiled and in mint condition, but it really does make a difference!

**NUMBER 2: HAVE A SHARP NEEDLE**

This is not such a big deal when stitching through paper since even a dull needle will pierce paper, but a dull needle can cause all sorts of headaches when sewing fabric.

**NUMBER 3: TOP THREAD = BOTTOM THREAD**

Always have the same weight thread in the bobbin and threaded through the needle. The bobbin casing has a tension setting (a small screw in the side) that feeds your thread through at a consistent rate. If you use different weight threads, the bobbin casing will pull your stitches toward the top or bottom of your fabric instead of keeping them in the middle. This can lead to uneven stitches, puckers along your seams and (worst case scenario), stitches that don't hold your fabrics together.

That said, all of these rules are bendable if you're willing to spend extra time adjusting your bobbin tension, rethreading your machine after your thread breaks for the millionth time, and fighting your fabric every stitch of the way. {wink!}

### notion

Sewing through paper requires much less machine maintenance than sewing fabric because paper is so fragile. Fabric, on the other hand, is woven; you need a sharp needle and an oiled motor to separate the fibers without snagging.

# Start Sewing!

Alrighty then! You've agreed not to be too hard on yourself, you've gotten your machine in order, and now you're ready to sew!

If you already know how to sew, you can skip to the next page. If you've never sewn before, you will really benefit from reading the basics in your sewing machine manual. Also, if you have friends or family who are willing to teach you, you should definitely take them up on the offer. The best way to learn a sewing technique is to watch someone else do it first. Then you just have to take a deep breath and try it for yourself.

Start by grabbing a piece of scrap fabric, folding it in half, and sewing from the top to the bottom in a straight line. It's as easy as that, honest! Once you've sewn a few rows in that manner, find the reverse lever. Instead of starting at the edge of your fabric, do the following: Use the lever to lower your needle into the fabric about $1/2$" (12mm) in from the top edge. Press the reverse lever down, and then gently step on the foot pedal. Sew backwards until you are one stitch away from the top edge, release the reverse lever, and continue stitching forward to the bottom edge. When you get about $1/2$" (12mm) from the bottom edge, reverse stitch again. This is called backstitching, and it knots your thread in the fabric by sewing over itself. Nifty, huh?!

There are all kinds of really good how-to books on the ABC's of sewing. Go to your library and check a couple of them out to use as a reference as you go through the projects in this book.

The last piece of advice I'm going to give you on sewing basics is to clip your thread tails short before continuing on to the next row. This keeps you from accidentally sewing over them, and causing a tangle on the back of your patchwork pieces.

Now that you've practiced on scrap fabric, you're ready to give patchwork a try.

## notion

If you haven't sewn in awhile, remember that your bobbin should spin counterclockwise.

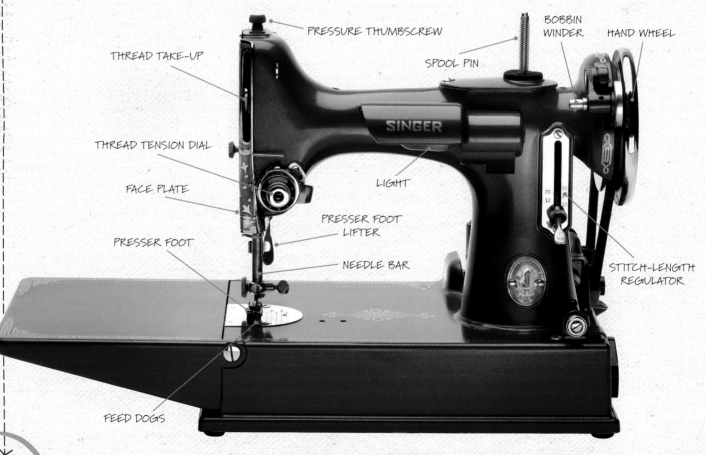

PRESSURE THUMBSCREW

THREAD TAKE-UP

SPOOL PIN

BOBBIN WINDER

HAND WHEEL

THREAD TENSION DIAL

FACE PLATE

LIGHT

PRESSER FOOT

PRESSER FOOT LIFTER

NEEDLE BAR

STITCH-LENGTH REGULATOR

FEED DOGS

*Whether you have a brand new sewing machine or an antique, like the one pictured above, most machines will have these basic parts. Use your sewing machine owner's manual for more information on how your machine operates.*

# Sewing Tips, Tricks and Techniques

Rather than focus on the basics, I'm going to share the sewing tricks I've come up with or learned from those who have taught and mentored me. Necessity is the mother of invention, and since I am mostly self-taught when it comes to sewing, I can get pretty creative when it comes to problem-solving. When I can't figure out how to do something, I look it up on the Internet, ask around or just make something up. The great thing about fabric is that it is very forgiving, and you can always grab a seam ripper or do a "mulligan" if you completely fail. I've chosen to embrace my imperfections when it comes to sewing, and focus instead on coming up with little tricks that fool the eye into thinking everything is accurate.

I am asked a lot what tools and type of sewing machine I use. I have a sixteen-year-old Elna with about twenty stitch types, and an old 1950s Singer slant-arm machine that's great for sewing heavy-duty materials like leather and layers of canvas. All you'll need for this book is a basic sewing machine with a couple of stitches.

You're going to hear me talking about texture a lot throughout this book. I'm a texture junkie and love discovering new ways to use it as a tool for making my creations as fun to touch as they are to see. One way I do this is by using the decorative stitches on my sewing machine. My favorite is the baseball stitch, which looks like a series of connected arrows. It's a fantastic stitch for hiding seams and creating borders. Another great stitch is the plain old zigzag. Experiment with varying the stitch lengths and widths, and switching between straight and decorative stitches. Just remember to place the needle in the "up" position when changing stitches, or else you risk bending or breaking the needle.

Different needles are made for various fabric weights and weaves, so make sure to change your needle according to your fabric choice. I tend to stick with a needle for heavy fabric (i.e. denim) because I frequently layer my fabrics, making them too dense for a lightweight needle.

# Sewing Necessities and Important Info

## basic tool list:

- ✿ black fabric pen
- ✿ disappearing fabric marker
- ✿ iron
- ✿ needles (sewing machine and hand)
- ✿ rotary cutter
- ✿ ruled straightedge
- ✿ self-healing cutting mat
- ✿ sewing machine
- ✿ scissors
- ✿ thread

## other useful items:

- ✿ beeswax
- ✿ extra sewing machine needles
- ✿ spray bottle with distilled water
- ✿ temporary fabric adhesive
- ✿ variegated thread
- ✿ Now just add fabric and a positive attitude, and you're good to go!

## important info:

- ✿ All seam allowances are ¼" (6mm) unless otherwise noted. This is the distance from your stitches to the edge of your fabric. Use a piece of painters tape to mark your sewing machine bed ¼" (6mm) to the right of the needle. You can use this mark to align your fabric, helping you maintain ¼" (6mm) seam as you sew.
- ✿ Sewing machine stitch length should be set to 2½" (6cm) unless otherwise noted.

# Patchwork Piecing and Sketchy Stitching

I have a little love affair going on with fabric, so to maximize my storage space, I buy a lot of fat quarters.

Add that to all this wonderful fabric I've been dyeing, and I have a huge collection of choices. Sometimes, however, I don't have enough of a certain fabric to fit a pattern's requirements. I started using the fundamentals of patchworking to solve the problem. This patchwork process combined with a technique I call *Sketchy Stitching* will give you great results for really fun, funky projects every time.

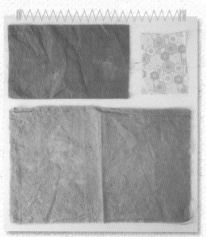

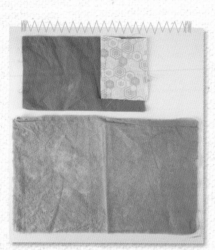

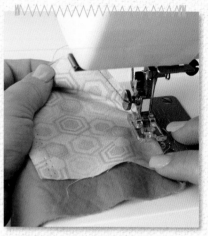

1 Start with 3 or more fabrics cut into rectangles or squares. How many pieces you need depends on how big the end patchworked piece needs to be. Here, I'm starting with 3 rectangles.

2 Place your smallest piece of fabric on top of an adjacent piece of fabric, right sides together, aligning the fabrics on the right side. Always work from smallest to largest pieces when patchworking. I'm right-handed, so I always line up my fabrics and sew on the right-hand side. If you are left-handed, you can switch everything over to the left, but follow everything else as written.

3 Place the aligned fabrics under the foot of your sewing machine. Using ¼" (6mm) seam allowance, stitch the 2 pieces of fabric together along the aligned side. Backstitch at both the top and bottom of the seam.

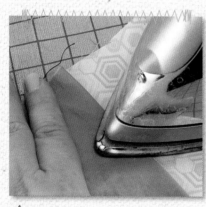

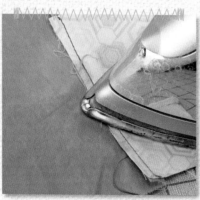

4 Open up your 2 pieces of fabric, and press your seam open with a hot iron.

5 Press the seam allowance towards the darker fabric so you cannot see the dark fabric through the light fabric.

## notions

- If you are piecing a material like vinyl that can't be pressed open, finger press the seam open, and sew down the edge of the seam on the vinyl side to keep it in place.

- If you are sewing really heavy fabrics, you should press your seam open instead of to the side to reduce bulk.

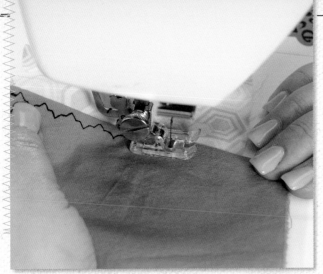

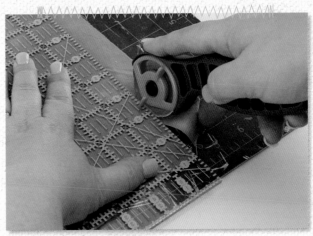

6 Place the open fabric panel right-side-up under the machine foot. Using a decorative stitch, sew once down either side of your seam. See how dramatic it is when you use a darker thread? Make sure the seam allowance on the underside of your fabric gets sewn down the way it was pressed. If not, you will have a lump in your patch-work piece.

7 Use your rotary cutter, ruled straightedge and cutting mat to trim down the uneven sides of your patchwork piece of fabric.

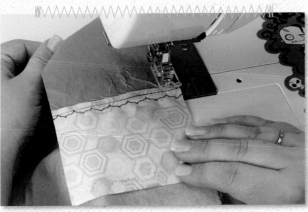

8 Keep adding scraps of fabric in this manner until you have a patchwork piece of fabric the size you need for your project. Add decorative stitches wherever you like. Trim the edges as you go so they are even and straight. Here, I've sewn 3 pieces of fabric together, and have a good-sized piece of patchwork fabric. Now it's time to add sketchy stitches for added detail and even more color. This technique will give you a bit of a free-motion look without having to master the art of free-motion sewing just yet.

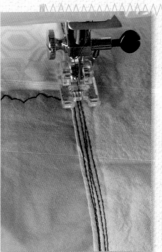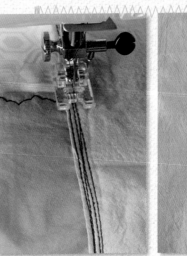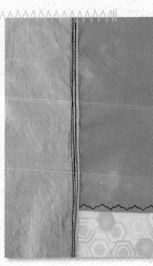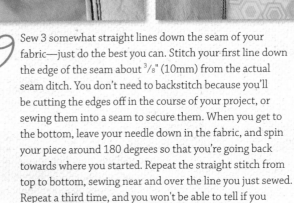

9 Sew 3 somewhat straight lines down the seam of your fabric—just do the best you can. Stitch your first line down the edge of the seam about $^3/_8$" (10mm) from the actual seam ditch. You don't need to backstitch because you'll be cutting the edges off in the course of your project, or sewing them into a seam to secure them. When you get to the bottom, leave your needle down in the fabric, and spin your piece around 180 degrees so that you're going back towards where you started. Repeat the straight stitch from top to bottom, sewing near and over the line you just sewed. Repeat a third time, and you won't be able to tell if you sewed a little crooked!

I'm all about seeing the stitches and using them to enhance my fabric and artwork, rather than trying to make them invisible. To achieve this look, choose high contrast, variegated threads that highlight your fabric and really stand out!

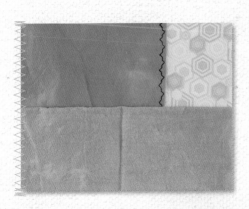

# Sketching with Stitches

I'm a mixed-media artist at heart, so I like to carry over my mixed-media techniques, like sketching, when I play with fabric. A great tool for gaining skill and confidence in your sketching is to buy an inexpensive journal and commit to drawing one thing every day until it's full. By the time you get to the last page in your journal you *will* see a marked improvement.

I love to draw and embroider, so I had the idea to stitch my own sketches. Many times, I have a sketch that I've drawn as part of my weekly art journaling and find that it would make a fantastic embroidered piece. Keep this in mind as you sketch and doodle in your journals! They are a great place to find embroidery inspiration.

I'm using a black fabric pen here so that you can see my sketch, but you may want to use a disappearing pen. After stitching over your sketch, just spritz it with a spray bottle filled with water, and *poof!* your lines disappear.

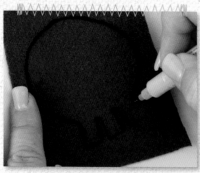

1 Practice drawing your sketch on paper before drawing on your fabric. Press your piece of material flat with a hot iron so that it's nice and smooth. Use your non-dominant index finger and thumb to hold your material down and taut while you draw. Use a fabric pen or disappearing marker to draw the outline of what you want to stitch. It's just like drawing on paper, except you have to go a little bit slower as you sketch so that you don't get skips in your ink line.

 notion

I like to sew with a thick thread, like one made for sewing buttons or upholstery. I find that it really shows off your stitches and doesn't break or snarl like other threads. I also love to use vintage tatting thread made in France. It has a really coarse texture that I just love to run my fingertips over. If your thread continually gets knotted up, run it through beeswax before sewing to solve the problem.

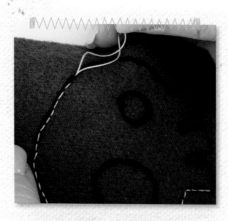

2 Using a needle and thread or embroidery floss, backstitch over the lines you drew. I don't double up my thread, and I always knot the end of my thread before I start stitching. At the finish, tie a knot in the thread on the underside of the fabric.

notion

To backstitch, come up through your fabric, leaving about an $1/8$" (3mm) gap between where you come up and the end of the previous stitch. Then, put your needle back down through the fabric at the end of the previous stitch.

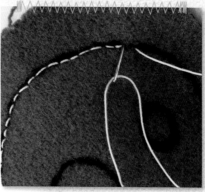

3 Stitch the entire sketch. The smaller your sketch/embroidered piece, the shorter you need to make your backstitches. This keeps your curved areas from looking choppy and makes your stitching flow better.

# French Knots & Kisses

I'm a huge believer in making touchable art, and I'm no different when it comes to my embroidered items and art quilts. One of the ways I add both visual and tactile interest is by adding cross-stitches and French knots with a thick thread on a textured material, like felt. I like to call them French knots and kisses as a reference to how I sign my personal correspondence with *xox*.

## KISSES

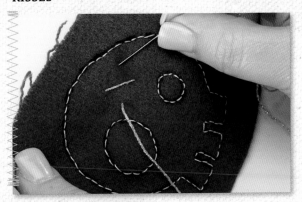

To make a "kiss", stitch a simple X anywhere you'd like. You now have art that begs to be touched.

## FRENCH KNOTS

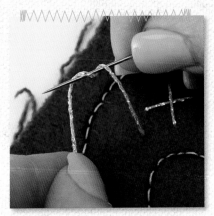

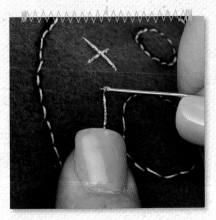

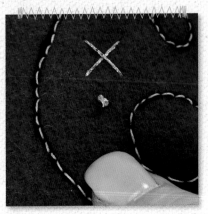

1 Come up through your fabric with your needle where you want the knot to be. Hold the needle almost horizontal in your dominant hand, and the majority of the thread in your other hand. Wrap the thread around your needle 3 times for a medium knot, and 5 times for a larger knot.

2 Using your non-dominant hand, gently pull the thread away from the thread-wrapped needle, and press it down with your thumb against the fabric about $\frac{1}{2}$" (13mm) from the needle to hold it in place. Push your thread-wrapped needle through the fabric in the same hole you came up through. Keep the thread taut and wrapped right up against your needle. Keep holding the thread taut as you pull through the fabric.

3 When you have pulled to where you are holding the thread, slowly let the thread go as you pull the needle through. The thread will tie itself into a nice little French knot for you. These knots can be a little tricky when you are starting out, but with a little practice you will be a French knot master in no time.

 notion

Something to keep in mind as you add embroidery: The human eye likes to see things in small odd numbers first, then in a pair, and finally just a single object. Keep this in mind as you add accent stitches. Try adding stitches in sets of 3, 5 or 7 to see which arrangement your eye likes best. This is called composition in the visual arts, and is a really nifty trick for getting people to like your art on a subconscious level.

Another neat trick is using curved lines and circles. Straight lines don't occur in nature, and instantly feel jarring to our eyes and minds. Using curves can be a great way to encapsulate your art and to pull your viewer in. Try adding small circles as accent stitches to enhance the flow of your embroidered piece.

It's also important to leave negative space in your stitching. If you jam pack your fabric full of stitches, the eye gets confused and looks elsewhere.

# Sew Simple Shapes

This is a great technique for cutting shapes out of two or more fabrics without them unraveling away into nothingness. It uses my *Sketchy Stitching* technique (page 24–25) as a springboard.

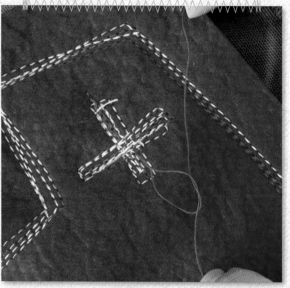

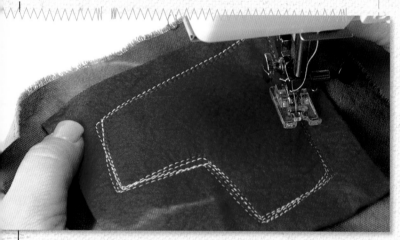

**1** Start with 2 pieces of fabric that are larger than your desired cutout shape. I like to combine something fluffy (like felt) with something smooth (like cotton), but it will work with any 2 fabrics. Place the fabrics wrong sides together, and sketch a simple shape on one piece with a pen or disappearing marker. Put your sewing machine needle down through both layers at a point along the outline of your sketch and backstitch to secure your thread. Here I've started at the bottom point of the heart.

**2** Using a contrasting or variegated thread, sew around your sketch or shape 5 to 7 times. Don't try to stitch directly on top of the previous row of stitches; vary the spacing a little on each go-round so that you get sketchy lines. This gives you a really blurred edge, hides any imperfections in your stitching, and interlocks your 2 fabrics together.

Go wild and *sketch* whatever your imagination can dream up inside your shape. Here, I've sewn a large **X** in my sketchy style. I like to stop sewing in the same place that I started, and tie my 2 top threads into a tiny knot. This secures your threads and adds another hidden bit of texture for curious fingertips to find.

 notion

If you notice that your variegated thread is changing color in the same place repeatedly, backstitch to secure your thread, and move to another point on your shape before continuing on. This will change up the variation repeat.

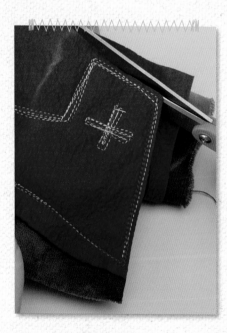

**3** To finish up, cut out your shape. Use a very sharp pair of fabric scissors, and stay at least ⅛"–¼" (3mm–6mm) outside of your stitches. If you snip any of them by accident, slide the shape back into your sewing machine and give it another go-round, being sure to cross over the part where you snipped into your stitches. You can also cut out the inside of your shape to create a cool fabric frame that you can then sew into any of your journal, mixed-media or sewing projects.

# Faux Felting

This is one of my favorite techniques, and it's the one I use most often to make something really special for my friends. I call this technique *Faux Felting* because, just like needle felting, it mashes two or more fabrics together to create one thick, amazing, malleable piece of fabric. It is an extremely simple process, although it is a bit tedious and time consuming—just listen to music, go into reflection-mode and sew away!

## notion

This technique stuffs a lot of lint down into your bobbin case. Clean out the debris every time you sew up a batch of faux felt!

1 Choose 2 materials, each larger than the shape you are going to cut out. I've found that this technique works best with at least 1 thick fabric like wool, felt or even an old sweater sleeve. When you use a thicker fabric, you have more to mash down into your ultra-felted piece. I'm using a bright orange piece of dyed bamboo quilt batting and a piece of wool suiting. These nice, fluffy fabrics will result in a wonderfully dense felted piece.

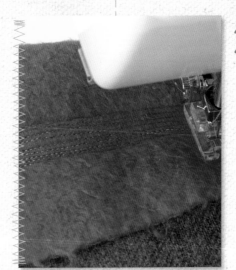

2 Lay the 2 material pieces on top of each other, wrong sides together, and slip them under the presser foot. Using a short stitch length and coordinating thread, begin sewing in the center and stitch out towards one edge. Then, snip your threads, go back to the middle and sew out to the opposite edge. Sew straight rows about ⅛" (3mm) apart, using the presser foot as a spacing gauge. Keep stitching parallel rows until you have covered the entire surface, really mashing and molding the fabrics together.

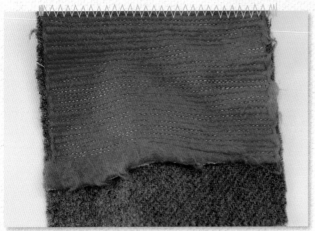

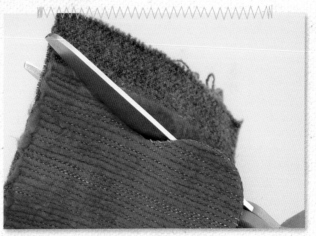

3 Once you've removed the fabric from your machine, if you feel like your rows are too far apart or that your fabrics aren't felted together enough, simply stick it back in your sewing machine and sew more rows until your felted piece looks and feels right. I don't know the physics behind it, but sewing fabrics together like this changes their composition and makes a pliable piece. You can use your thumbnail to give it a curl, like a ribbon. Sew multiple pieces together to create 3D creatures, like the *Bluebird-of-Happiness Pincushion* (page 66).

4 One of the neat side effects of this process is that as you mash your layers together with your sewing machine, you actually stretch them out of shape, a bit like using a rolling pin on pie crust. This means that you can cut out any shape and your fabrics won't unravel or fray. Since I used autumnal colors for my example, I decided to make a pumpkin shape. Use a sharp pair of fabric scissors to cut out your shape. Your faux-felted shape is fantastic to use as a background in another mixed-media project, or to be turned into a handmade message. Use this technique to make leaf embellishments for the *Out & About Purse* (page 90).

## Graffiti Style

When working with print fabric that's too wonderful to dye, you still have the option of altering the print to fit any mood or project. Just like graffiti on a building, train or subway car, the sky's the limit when it comes to drawing on fabric.

I've always admired graffiti artists; the over-whelming urge to add color to the drab and mundane is just plain impressive to me. My musings with my mentor, Sarah Fishburn, about what makes great graf-fiti first put the thought in my head of drawing on fabric in a similar raw style.

Sometimes, drawing on fabric can be as simple as adding a fine black outline around one design element, writing your favorite word big and bold, or adding white polka dots with a gel pen. Other times, there may be room to doodle with reckless abandon. It's all up to you!

Today, there is an amazing array of fabric pens and markers, and they are fabulous for drawing on cotton prints. Experiment with these, as well as the pens and markers you have lying around the house. You can use them on a variety of materials, but I find cotton gives you smooth lines with very little bleeding.

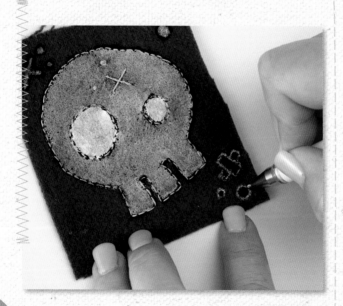

## Painting on Fabric

Before you run off into the projects part of this book, I want to touch on using acrylic paint—I still have some tricks up my sleeve that I'd like to show you. For this example, I'm using a bit of sky blue craft paint and some medium viscosity artist paint in white. I like to mix a watery craft paint into a thicker artist paint when painting on fabric with a higher nap because the paint gets down into the fibers better. Everyone likes their paint a different consistency, so experiment until you feel comfortable with the process.

Squeeze a bit of your two paints onto a paper plate and use a small filbert paintbrush to mix them together—now you have three colors instead of two (white, sky blue and blue-white mix).

Starting with the sky blue craft paint, smooth and spread the paint onto your fabric piece. Use a dab-bing motion on dry parts of the fabric, and spread the paint outward until you feel the fabric really pulling on your brush. Continue until you've filled in your entire shape.

Let this coat dry for a few minutes and then go back in with the blue-white mix. Starting in the center of your piece, add the blue-white mix from the center outward. Stop whenever you get about $1/4$" (6mm) from any stitching or drawing. Be sure to retain some dark areas to show shading. Use the pointed end of the paintbrush or a pencil eraser tip to create dots around your embroidery pattern or design.

Let the blue-white coat dry for a couple of min-utes, and then add highlights with the white artist paint. I painted the inside of the eyes white so that they would really pop out. If you're unsure of where to add the highlights, think of where the sun shines on an object or on your face—this is where you want to add highlights.

After your paint dries completely, add more details with fabric paint or permanent pen. I like to outline my embroidery stitches in black. Using both light and dark elements in your art adds depth and makes peo-ple want to lean in close to get a better look. Our eyes are hungry and good artwork is like candy to them!

# Dry-Brush Painting Technique

Another nifty paint trick is to drybrush highlights and shadows onto things like clothespins, chipboard, craft wood, etc. When using acrylic paint, begin with your darkest color and add lighter colors from there.

Choose three colors to work with, one of them white or light. With a medium flat-tipped paintbrush, give your chipboard (or clothespin, etc.) a good coat with your darkest color (here, I used blue). This creates a good base and will allow your additional paints to spread better. Make sure you also paint the sides of your object.

While the first coat dries, wash your brush out. Then, dry your brush off really well before you move on to the rest of this process. Dab the tip of your flat brush into the medium color (here, I used green), and tap it down on a paper towel until only a tiny bit of paint is distributed evenly across your brush tip.

Holding your paintbrush vertically, brush it back and forth across the top of your object so that it paints on the top only (not the sides). I start on a diagonal and go back and forth from right to left quickly. It's almost as if you are trying to brush lint or dust off the surface of your object very quickly. Do this for a couple seconds in one direction, and then go in the opposite diagonal direction.

Let this layer dry for about half an hour, and then scrub the darker color across the surface diagonally both ways, but only for a second this time, and sticking more to the outside edges. This adds a little bit of dark paint around the outside edges to create depth and shadow. Let this coat dry for about ten minutes, and repeat with the lightest color. Mix a tiny bit of white with the medium color. Use this paint to highlight various places (like the beak on my chipboard bird) by brushing across the center of your object instead of the edges.

Lastly, add a dark coat again, but only around the very outside edge. You will end up with a center that seems to glow out from behind your darker edges.

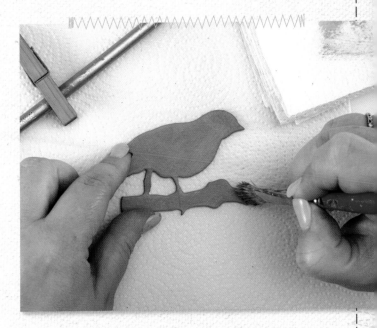

# Sewing Unusual Items

I've found that with a bit of ingenuity and the right tools, you can sew almost anything. If you want to try sewing odd objects to your art, I would suggest investing in a Dremel or drill press. These tools will allow you to create holes in hard objects that you can later stitch through with thread or twine.

Do some research to make sure you are using the correct drill bit for the material you're drilling—there's a drill bit for just about everything these days! Avoid pressing down too hard when you drill, and let the drill do the work for you. Be careful not to burn yourself—the bit can get hot if you use it for a long period of time. Also, use a small vice or good pliers to hold your object steady while you drill; this keeps the objects from spinning with the bit as you drill, and helps you avoid cutting yourself.

Not all unusual objects require a drill to sew through. Thin metal objects like bottle caps can be pierced using a hammer and nail. Place your metal object on a piece of scrap wood, and hammer the nail through the object to make a hole. Remove the nail and *voilà!*—you have a hole to sew through.

These methods allow you to make just about any found object stitchable. Beware of sharp edges around your holes—they can cut your fingers and your thread.

Now, go find something unusual and give it a go!

# 2 idea catchers

I'm one of those lucky people who always has more ideas bouncing around in my brain than I can keep track of. For the longest time, I would get a great idea and try to keep it alive in my mind. This never worked very well—I was constantly forgetting and losing really good sparks of inspiration. With everything else jostling around for attention in there, it's no wonder I had very little success.

To combat this idea leak, I came up with four ways to hold on to my ideas. Keeping an art journal has been invaluable in this area, and so I'll show you how to create your own *Daydream Sketchbook* (page 38) to capture your creative sparks. If you're like me, you get a lot of inspiration from other artists, fabrics, colors and tidbits. An *Inspiration Board* (page 34) is a fantastic way to keep all of your most inspiring objects in your line of sight while you create. One of the most exciting projects in this section is the *Dye Recipe Book* (page 42). You'll see how to use the leftover brown wrap and paper towels from your dye experiments to keep a running journal of your concoctions and dye swatches. This chapter rounds out with a *Canvas Project Protector* (page 46) which helps you visualize your project concept and determine if your materials will play nicely together. It's the perfect solution for fleshing out an idea that's still trapped inside your noggin.

i•dea

noun

• a transcendent entity that is a real pattern of which existing things are imperfect representations

• a standard of perfection

• a plan for action

excerpt, *Merriam-Webster's Collegiate Dictionary*, 10th ed., s.v. "Idea."

# Inspiration Board

I can't tell you how important it is to find people and things that inspire you. There is nothing better than having something ignite a spark in your mind that drives you to create something spectacular. One of the best ways to fuel this process is to gather all the little things that inspire you, and display them on an altered cork board in the place you create. My inspiration board is a quick and easy way to do just that. Even better is that you can easily change the quilted backing to reflect whatever colors inspire you at the moment by simply popping off staples. You then have pre-quilted fabric to use in another project.

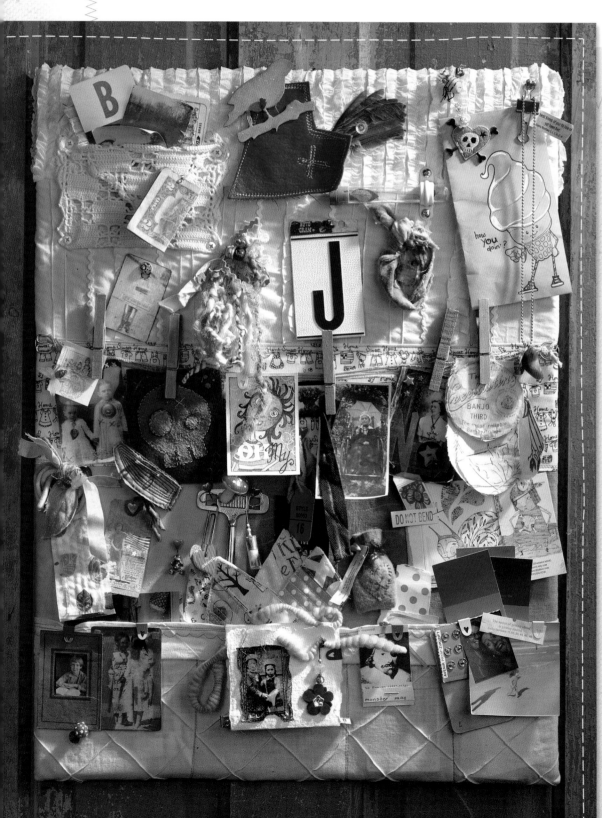

## materials

✿ fabrics:
- 3 contrasting fabric strips, each 6" × 28" (15cm × 71cm): 1 light textural, 1 dark textural, 1 novelty print
- 24" (61cm) cotton ribbon
- 2 dyed fabric rectangles (22" × 28" [56cm × 71cm] total pieced dimension)
- 7" × 10" (18cm × 25cm) piece of vintage lace
- 18" × 28" (46cm × 71cm) textured fabric strip (pocket)
- 24" × 30" (61cm × 76cm) low-loft bamboo quilt batting

✿ acrylic paint (to coordinate with fabrics)

✿ 3–5 clothespins

✿ 18" × 24" (46cm × 61cm) corkboard

✿ hot iron

✿ inspiration tidbits

✿ light-duty staple gun

✿ paintbrush

✿ Phillips-head screw driver

✿ 2 picture hanging kits

✿ sewing machine

✿ thread

✿ 4 white sheet metal screws

1 Lay a piece of 24" × 30" (61cm × 76cm) quilt batting flat on a sturdy surface. Place your corkboard in the center of the batting, front-side-down. Wrap the batting around the back of the board and staple it down, starting in the middle of each side and working outward. Set the board aside.

2 Using the instructions on pages 24–25, piece your dyed fabric rectangles together to create a 22" × 28" (56cm × 71cm) rectangle. Press the seams to one side. This rectangle will be your fabric base. Everything else will be sewn on top of this pathwork fabric base.

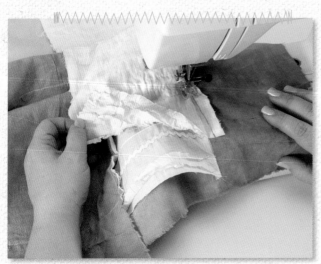

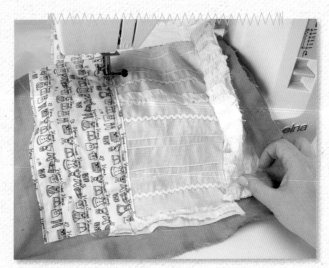

3 Stack the two textural fabric strips right sides together, and lay them across the width of your base fabric 5" (13cm) from the top. Turn the whole stack clockwise 45 degrees. Now the top of your fabric base and your stack of textured strips are all on your right. Straight stitch along the right side of the 2 strips twice, sewing the strips together and down to the fabric base. Make sure to catch both fabrics in the seam.

4 Open the stacked fabric up, and press open your seam. Fold under a 1" (3cm) seam on both long edges of your novelty print strip, and press with a hot iron. Place it right-side-up on top of your fabric base so it overlaps the left-hand textured fabric by 1"–2" (3cm × 5cm). Use a decorative stitch to sew both long sides of the novelty piece onto your base fabric.

 notion

Lay your corkboard on top of the right side of your
base panel. Lightly mark with a pencil 1" (3cm) past
the edges of your board on your fabric so that you
know how far out your strips need to be to completely
wrap around the sides of the board.

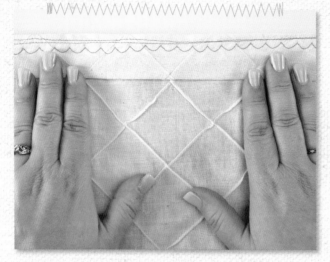

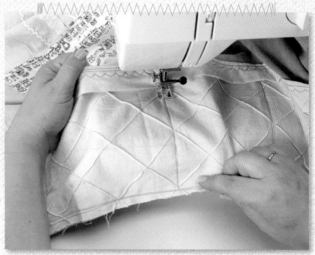

5 To create the bottom pocket, take your remaining textured strip, fold under a 1" (3cm) seam on 1 long raw edge, and press with a hot iron. Fold under 2 more times so that your fold is 3 layers thick. Topstitch along this folded edge 2 times, and then sew a decorative stitch underneath.

6 Lay this pocket piece on top of the base fabric, aligning the raw edge of the pocket with the bottom raw edge of the base fabric. To create the pocket, sew around the sides and bottom of the strip, being sure to sew through all layers of fabric. Sew vertical lines from the bottom edge to just under the folded top in varying places to create smaller pockets. Double stitch these seams for added strength.

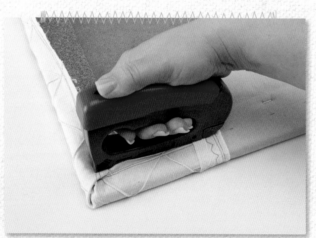

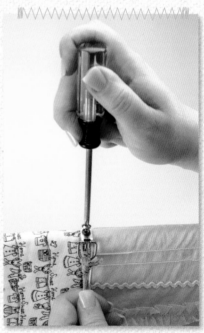

7 Lay the quilted base on the front of the corkboard, making sure the strips and pockets run straight across the board. Smooth the fabric so it's flat, and carefully turn the whole thing over. Wrap the excess fabric around the back of the board, and staple every 3" (8cm) all the way around, just like you did with the quilt batting. Pull tight and smooth as you go. Staple the corners last, tucking them in like you would wrap a present.

 notion

Put lots of staples in the bottom edge of the board to secure the bottoms of the pocket so things won't fall out! You can also use fabric basting spray to help hold the fabric base on the cork.

8 To make the clothesline, use the mounting brackets and screws from a picture hanging kit. Securely tie 1 end of your cotton ribbon around a mounting bracket. Lay the angled side of the mounting bracket around the outer edge of the board. Screw into the outer edge of the board. Be careful not to force the screw further than it wants to go or you'll shred the corkboard.

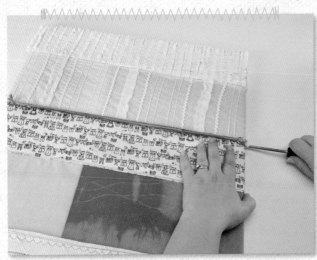
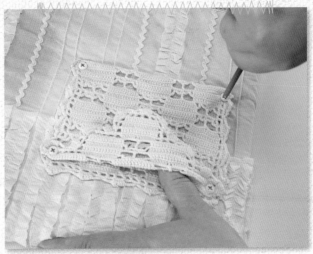

9 Pull the ribbon across the width of your board until it is taut and comes slightly past the edge of the board. This is the length of ribbon you need. Cut off the excess ribbon and tie the end securely to the other mounting bracket. Attach the mounting bracket to the other side of the board in the same way as you did in Step 8. Install the second picture hanger on the back of the board following the manufacturer's instructions.

10 To create another small pocket, use a 6" × 10" (15cm × 25cm) rectangular scrap of vintage lace or fabric. Fold the lace into a pocket by folding the bottom up more than halfway, and then folding it back down 1" (3cm) to form a flap. With white sheet metal screws, screw the 4 corners of the pocket into your corkboard. (If using fabric, sew the sides together first to help hold the pocket closed.)

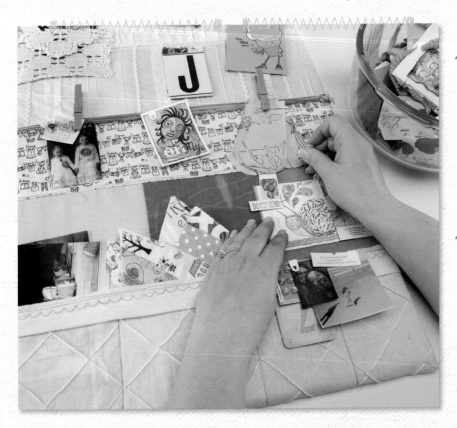

11 Paint several clothes pins using the *Dry-Brush Painting Technique* (page 31) using coordinating paint colors. Once the clothespins are dry, clip them to your clothesline and use them to hold up things like artist trading cards, photos, color swatches and business cards from artists you admire and love.

12 Now comes the fun part! Begin decorating your board with items that spark your inspiration. Use decorative pushpins, screws and antique hat pins to attach small items. Put things in the pockets so that they peek out the top. Clip, pin and tuck your favorite keepsake items, pictures, quotes, illustrations, found objects, swatches and bits of materials to your inspiration board!

# Daydream Sketchbook

Until a few years ago, I'd been resistant to journaling because I thought I lacked the time to make it worthwhile. However, I've become enthralled with sketching and art journaling, and find them a fantastic keeper of quotes and definitions. Journals also do a marvelous job of helping flesh out new ideas. I love that I can take my art journal on the go with me everywhere—it's kept me company through countless orthodontist appointments. I like to work in smaller-sized blank journals, but they come in a variety of shapes, sizes and colors these days. Use these daydream creations to inspire your next full-sized work of art!

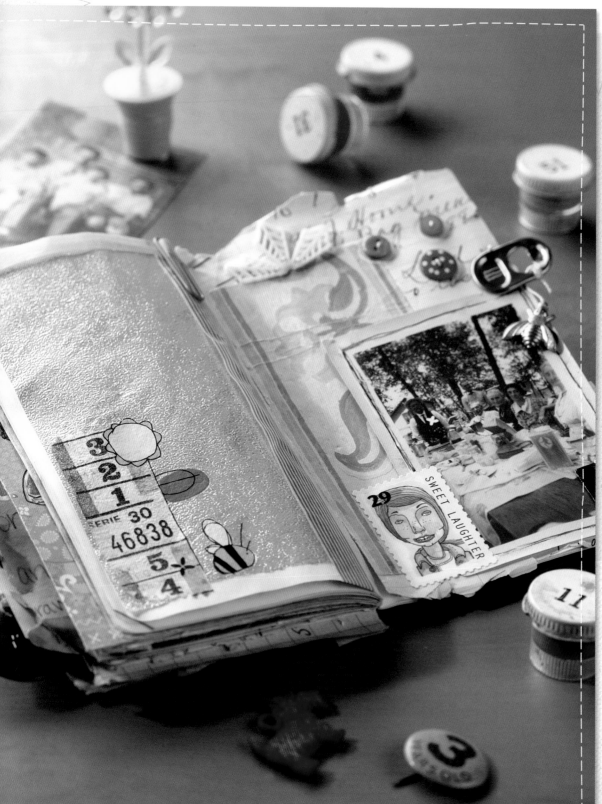

## materials

- black chipboard shapes
- black fine-tip art pen
- buttons
- craft glue or adhesive dots
- crayons or colored pencils
- dyed fabric scraps
- flat found objects
- gel or liquid matte medium
- Moleskine Cahier or Volant journal
- paintbrushes (assorted)
- papers (variety)
- rub-ons
- vintage ledger or book page(s)
- white gel pen
- optional: needle and thread, stapler

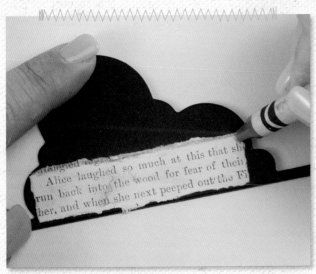

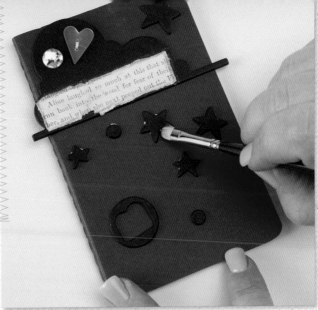

1 Start by choosing various chipboard pieces for the cover of your book. Punch them out, and embellish with snippets of text, buttons and ink. Try tearing out your text to give it raw edges, and add color with your favorite color of crayon or colored pencil, or by using the *Dry-Brush Painting Technique* (page 31).

2 Glue all of your chipboard to the cover of your journal with craft glue or adhesive dots. Be sure to press everything down firmly so it can withstand repeated opening and closing. Clean up any glue that has leaked out around the edges with a small paintbrush. For best results, allow it to dry for several hours or overnight. If you want to add more texture, try stitching on the chipboard with interesting buttons or simple embroidery stitches.

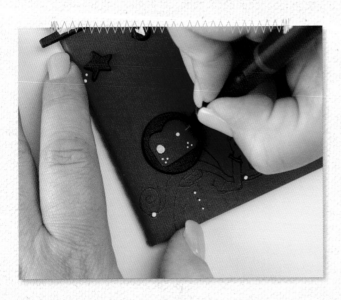

3 After the glue is dry, draw on and around the chipboard with a white gel pen. Outline letters and shapes, draw hearts, dots or stars inside and around shapes. Using a black fine-tip art pen, sketch something whimsical like a person or motif on the cover. Outline the white elements with the black pen, and add even more depth. Now it's time for the fun part—art journaling inside!

 notion

I love to use adhesive dots because they don't require any drying time and can be taken anywhere.

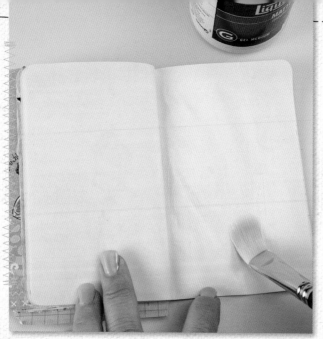

 notion

These little journals are great places to try out new techniques or mediums you've never tried before. It's up to you whether you show this journal to anyone or not, so take risks and try new things!

4 Prep your pages by painting on a smooth coat of matte gel using a medium-sized paintbrush. I personally like liquid matte medium because you don't have to apply as much, and the pages don't stick to the paintbrush as you brush it (as with gel medium). Make sure to paint all the way to the edges. Some wrinkling is normal; your pages should flatten out as the medium dries so don't panic.

If you're totally against matte medium, skip it and use double-sided tape in the next step.

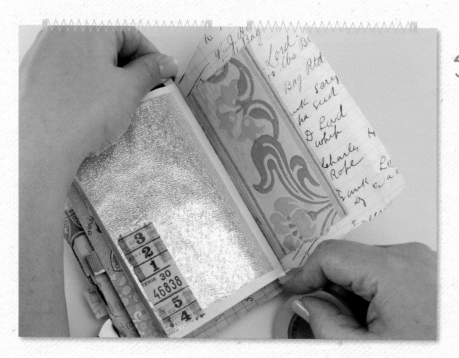

5 While the medium is still wet, glue down a background paper first, and smooth out any bubbles or wrinkles. This will be the base for the rest of your layers. Next, start glueing, taping or stapling more layers of papers and fabric scraps onto your background paper. Try overlapping the papers slightly, and let them spill past the edges of your journal. Use the same techniques you would for creating mixed-media art.

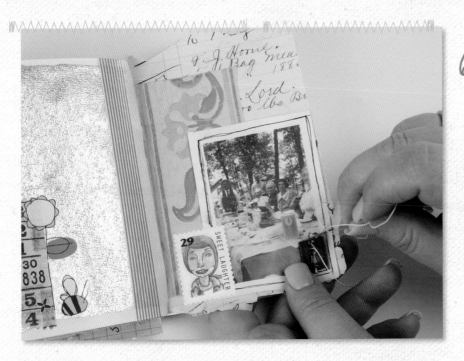

6 Continue to decorate your pages using vintage pictures, decorative tape, buttons, rub-on words and images, and flat found objects. Doodle around your papers and objects with pens and other art supplies. Sketch, outline and highlight the things you like the most or that catch your eye. Sew on buttons, beads and other found objects that add interest and texture to your pages. Don't worry about the back of the page—you'll cover that up in the same way when you move on to the next entry.

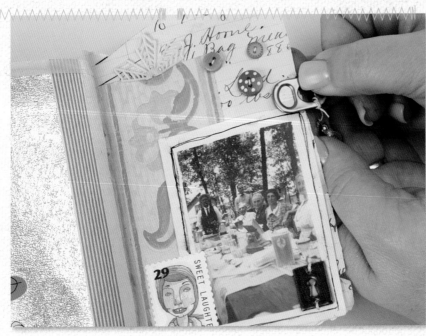

7 I really like to let things spill past the edges of my pages. Try attaching something like a pop-can tab or a vintage bus ticket to the side of the page with a glue dot to create a page tab. You can make tabs out of virtually anything that inspires you. And remember: If you can't glue it, sew it!

## notion

Don't forget to put your name, a theme or (at least) a date somewhere on your journal so you know when it was created. Art journaling can be an amazing tool for collecting ideas, and it's therapeutic to boot! Gather together all kinds of decorative and printed papers with similar or complementary color schemes—think along the lines of vintage ticket stubs, old ledger pages, pages from your favorite books and even textured scrapbook paper or fabric. Art journaling is very personal, and all of us do it differently. You'll discover your own unique journaling methods as you go!

# Dye Recipe Book

This is a really fun project for cataloging all your dye recipes using the brown postal wrap you used to catch spills during the dyeing process. The idea came about as a I was trying to find a solution for keeping track of all my dye concoctions. In the beginning, I jotted the recipes down on the inside of the dye packets, but eventually that method got too messy and unruly. Luckily, I had saved all the craft paper I used to keep my counters dye-free to use down the road. When my dye packets got out of control, I got the bright idea to turn the paper into a colorful recipe book, using the wrap as the pages! With a little work and a lot of imagination you can compile one for yourself.

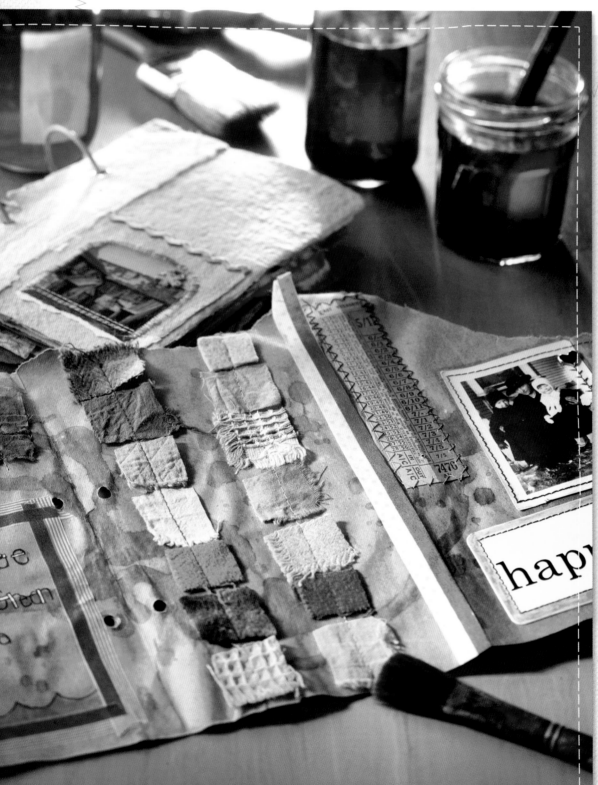

## materials

- black ink pen
- (2) 2" (5cm) book rings
- buttons, beads and charms
- clear hole reinforcers
- coordinating handmade paper pieces/scraps
- dyed fabric swatches
- dye-splattered craft paper (from the dye process)
- flat found objects
- hole punch
- Japanese Washi paper tape
- pencil
- ruled straightedge
- scissors
- sewing machine
- thread
- vintage ledger or book pages
- white gel pen

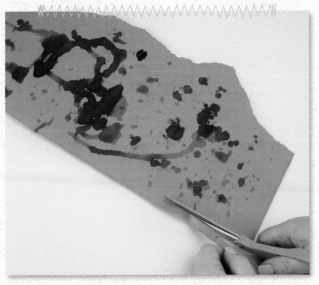

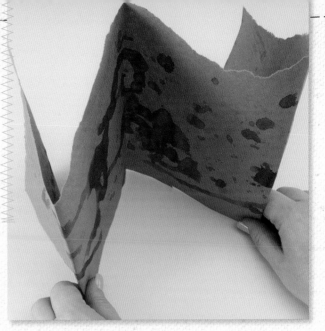

1 Create pages from the brown craft paper you used to catch spills during the dye process. Tear a long jagged strip off the top of the paper. Use a pencil and straightedge to draw a straight line across the bottom. Cut straight across the bottom edge to create a piece of paper the page height you want, leaving the top edge jagged. My pages are roughly 7" (18cm) tall and 20" (51cm) long at this stage.

2 Fold the brown wrap in half, right sides together. Then, just like an accordion, fold each side in half again, wrong sides together, back toward the center fold. The paper should now look like a **W**.

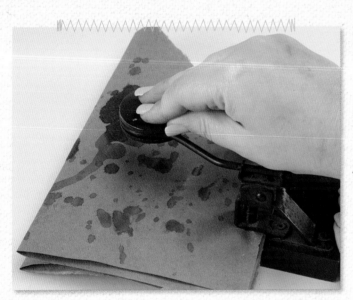

— RECIPE BOX

3 Use a hole punch to punch 2 holes through the center fold and ends of the paper. Stick clear hole reinforcers on both sides of the holes to keep the pages from tearing out as you turn the pages.

Now comes the fun part: Collect photos, postcards, ticket stubs, transparencies and any other found objects that inspire you. Tape or mark off an area to write your recipe in later. Be creative in the placement and orientation of your recipe box. Embellish the recipe box border with doodles, chipboard, buttons and anything else that strikes your fancy.

## notion

To create my recipe box border, I like to use Japanese Washi paper tape, but you can use tape of any kind. You could also simply doodle a box with your favorite pens or markers. Let the color of you fabrics spark the theme for the pages, the ephemera you attach, and the name of your custom dye!

# notion

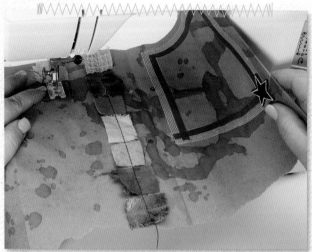

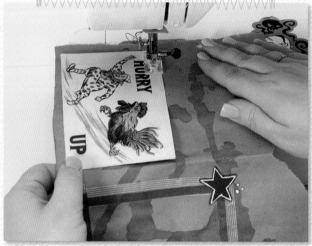

4 Cut a 1" (3cm) square swatch from every fabric that came out of that dye lot. Using a medium stitch length, sew your swatches onto a center page of your dye-splashed craft paper. Start sewing at the top of the page and butt each consecutive swatch under the swatch above it, creating a column of fabric. Continue sewing on all your swatches until they are gone. I like to use variegated thread to add visual texture, but it also looks marvelous to use a thread that disappears into the fabric, letting the colors shine.

5 Start sewing embellishments onto the remainder of your open craft paper space. I like to sew on things like vintage postcards, antique photos, ticket stubs, and other found paper or fabric items. Embellish right up to and even over the folds and edges of your craft paper; this will make the pages stronger and thicker.

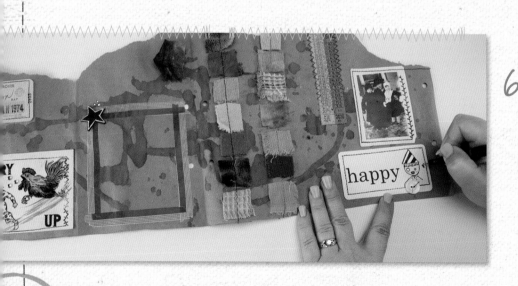

6 Use a permanent ink pen to doodle figures or designs onto the blank parts of your page. I also like to sketch around the edges with things like gel pens, crayons and markers. All of this adds color and visual interest.

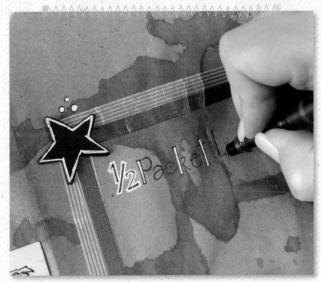

7 Now it's time to name and record your dye recipe in the space you marked off earlier. I prefer to use a black fine-tipped ink pen, but pretty much anything will do. Then, go back and highlight the letters with white pen. Outlining dark doodles with a white gel pen (or vice versa) really makes them pop. Continue to create pages for each of your dye lots until you have a unique and truly special collection of recipes.

 notion

If you don't like your hand-
writing, you have a multitude
of options. Use scrapbook
stencils, stickers or a Cricut
to cut out your letters. You
could even type out the recipe
on a vintage typewriter and
then paste or sew it in. Use
your computer set to a decora-
tive font, and print it out
on a piece of handmade paper.
I recommend you use your own
handwriting—the more your
write, the better it will get,
and the more you'll come to
like it!

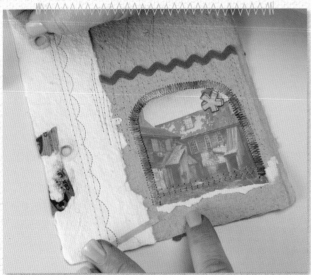

8 I made a front and back cover for my recipe book by com-bining several handmade papers. Stack and sew several layers of papers on top of each other to make a thick and sturdy cover. Embellish the front using any of the above techniques, or even ones from the *Daydream Sketchbook* (page 38). Using your interior pages as a reference, mark your hole spots on the covers with a pencil. Hole punch the covers just like the interior pages, and use clear hole reinforcers to keep them from tearing.

9 To bind your *Dye Recipe Book*, stack all of your interior pages together, and place them in between your punched covers. Once you have a stack, simply align the holes and use large book rings to hold everything together. Using these book rings allow you to add new pages as you create additional dye lots without having to rebind the book each time.

# Canvas Project Protector

It's not always enough to simply journal about an idea for a future project. Sometimes, it saves time to know upfront whether it's possible to create what you see in your mind, and if the materials you're thinking about using will really work together. Just like other industries mock-up their ideas using clay, paper or foam models, you're going to make a project mock-up using canvas, fabrics snippets and embellishments. This will give you a fantastic idea of what your finished piece will look like, and it will be a fabulous keepsake to save.

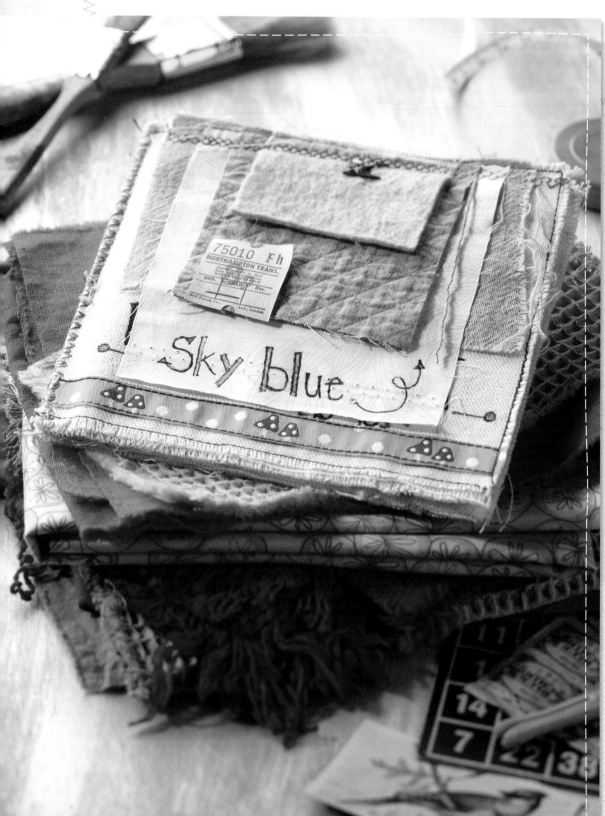

## materials

- 5" × 10" (13cm × 25cm) canvas scrap
- craft glue or adhesive dots
- fabric pens
- hot iron
- material snippets/swatches
- ribbons, buttons and other embellishments
- rotary cutter
- ruled straightedge
- self-healing cutting mat
- sewing machine
- sewing needle
- spark of inspiration!
- variegated thread
- white gel pen
- *optional:* stapler

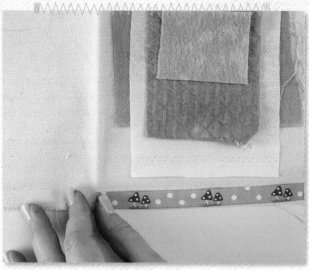

1  Using a rotary cutter, ruled straightedge and cutting mat, cut three 5" (13cm) squares from your material snippets and swatches. Fold your piece of canvas in half so that it measures 5" (13cm) square, and press with a hot iron. (I prefer to use un-gessoed canvas which comes on a roll at finer art supply stores. If you can't find any locally, you can use the gessoed kind that comes in a pad. Simply fold your canvas so that the gessoed side is hidden inside the fold.) Lay out the materials, notions and embellishments that you are considering using in your fabric project so you can get an idea of how you want to combine them.

2  Open your canvas page up so that it is shaped like a tent in front of you. Start by layering the fabric swatches on the right half of the page in a way that lets you see bits of everything. They can overlap, but don't place 1 piece entirely over another. Line them all along the top edge of the page so you can sew through all of them at once.

 notion

Try using the selvedges of both the canvas and your material snippets. This keeps the edges of your fabric that aren't sewn from unraveling, and creates a really interesting visual texture.

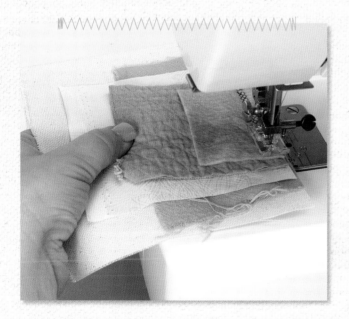

3  Place your page under the foot of your sewing machine. Using a straight stitch, begin sewing along the top edge through all layers of the fabric snippets. (If it won't easily fit under your foot, it's too thick for your sewing machine. If that happens, try using staples to attach the snippets to the page.) Use the thread you want to use for the real project to sew down the swatches—this way you can test the thread color with the fabric. You can add a few decorative stitches if you like, but make sure that you can still open up the layers of fabric to see which materials you've used.

 notion

Don't fill up every blank space with fabric. You will need some blank areas to write in notes and draw sketches of your idea.

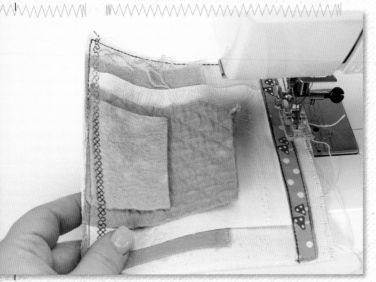

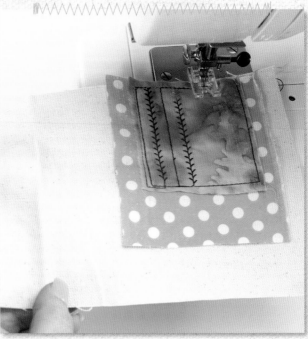

**4** Sew on any ribbons or trims , and add buttons, embroidery, staples or anything that needs to be done by hand. Add elements to the top of the page only—leave the back side of the page blank. Fold the page back in half, embellished sides out, and sew all the way around the outside of the 3 open edges. You don't need to sew along the folded side—this will be the bound edge of your booklet.

**5** Move on to your next canvas rectangle. This time, quilt your swatches, sew them to different edges, overlap them a bit, or wrap them across the folded edge. Add other fabric elements, such as ribbons and zippers, to both sides of your canvas rectangle. Remember not to overlap the center fold with anything hard, like a button or a zipper or it won't bind properly. Try out different decorative stitches to see how you might use them in your project, and try using variegated thread. This is your chance to see how things go together!

Fold the page in half and sew around the edges just as you did in Step 4. Repeat to make a third page.

 notion

If you are using synthetic ribbon, melt the cut ends with a lighter so they won't unravel. Just wave a lighter quickly back and forth below the end of the ribbon until you see it start to melt.

# notions

Ideas for making more pages:

- Try sewing the fabric you are going to use for the back of a pillow or quilt to the back of the booklet to simulate the feel and look of your actual project.

- Try sewing the edges of a strip of fabric across the fold of your canvas. When you put the book together, this piece of fabric will show up on 2 pages, wrapping around the spine.

- It's not necessary to sew around all 4 sides of every fabric swatch. Leave them sewn across the top like a flap or on 3 sides like a pocket.

- If you are going to stitch one of your sketches on your project, do a smaller version here as a trial run.

NOTE: WHEN CHANGING BETWEEN STITCH TYPES, ALWAYS RAISE YOUR NEEDLE UP OUT OF THE FABRIC OR YOU RISK BENDING OR BREAKING YOUR NEEDLE.

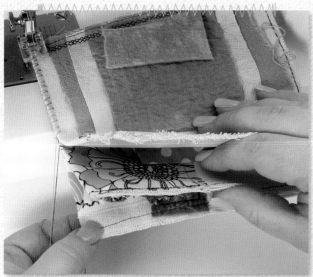

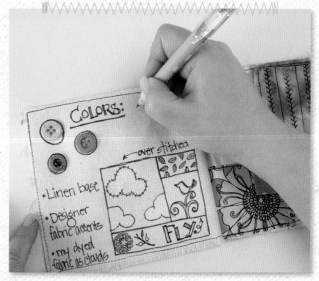

6 Stack your 3 sewn pages on top of each other, matching up the folded sides. Center the stack under your presser foot so the foot is aligned with the left edge of the spine. Sew a zigzag stitch from the middle of the spin to the end. Turn your booklet around and zigzag back the entire length of the spin. Finally, turn around once more and zigzag back to the middle where you started. Remove the book from under the presser foot and tie a knot with the thread ends. Snip off the excess thread, leaving 1/4" (6mm) tail or less.

7 Glue on additional found objects or items similar to what you would use in your full-sized project. Use fabric pens to write the project title on the cover of the mock-up. In the blank spaces you left in the interior of the book, write notes and draw sketches of how you plan on making your project. Doodle around things like buttons, and around the designs in your print fabric. Now you have in your hands a mock-up of what you only saw in your imagination before!

# notion

When using colored fabric pens, you can go over them with a white gel pen to blend the colors into lighter shades.

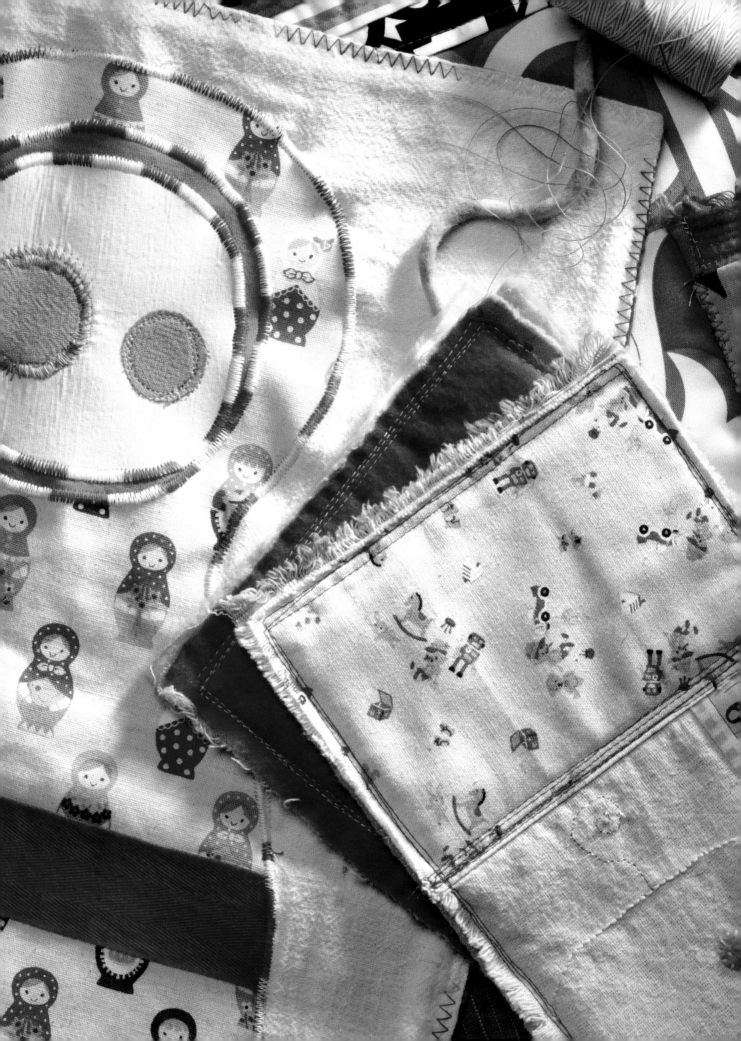

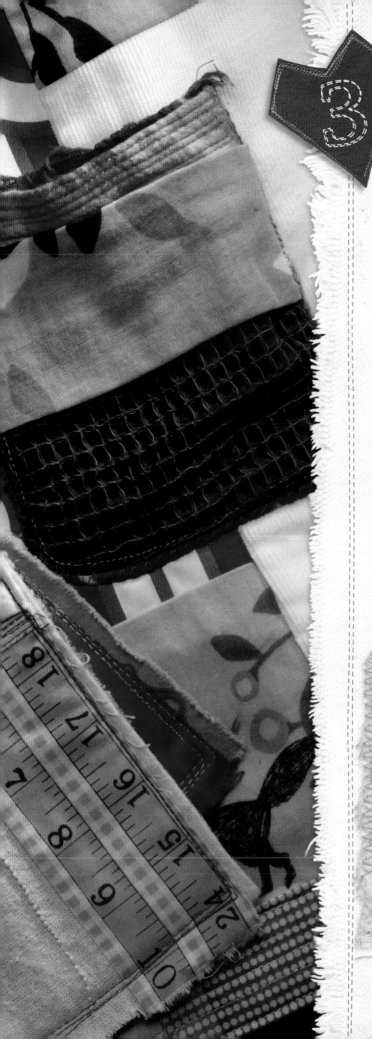

# 3 stitch yourself silly

I can't explain why, but I simply adore stitching. If I can poke or drill a hole in something, I'm going to try stitching it to fabric or paper. Period. Maybe it's because of the meditative effect sewing seems to have on my mind, or maybe it's the joy I get from creating something with my own bare hands. Or maybe it's simply because I like to poke, stitch and manhandle objects, making them bend to my will! {smirk}

Whatever the reason, it gives me enormous pleasure to sew things together. It's in that spirit that I give you a chapter full of projects that will let you stitch yourself silly, like me!

I'll show you how to make some awesome fabric home goods that are sure to make you smile. I'm a huge fan of zakka (the Japanese art of crafting anything that improves your home, life and appearance), and have engineered this chapter around that concept.

You'll be turning all of those colorful pieces of dyed fabric into things you can wear, use and poke pins into. It just doesn't get much better than that!

## stitch

**verb**

- to fasten, join, or close with or as if with stitches

- to make, mend, or decorate with or as if with stitches

**noun**

- one in-and-out movement of a threaded needle in sewing, embroidering, or suturing

- a single loop of thread or yarn around an implement (as a knitting needle or crochet hook)

excerpt, *Merriam-Webster's Collegiate Dictionary*, 10th ed., s.v. "Stitch."

# Art Apron

Handmade aprons hold a special place deep in my heart. My grandmother and mother have worn them my whole life, whenever they cook at family gatherings. If that wasn't enough to make aprons near and dear, they were the first and only piece of clothing I was brave enough to try after a jumper-set fiasco seventeen years ago. My first aprons turned out amazing and gave me the courage to keep on chugging full steam ahead. I've sewn handfuls of aprons since then, and love each one more than the last! So, take a deep breath, my friend, and let's hold hands as we run off the end of the dock and jump feetfirst into the waters of patchwork-style apron making!

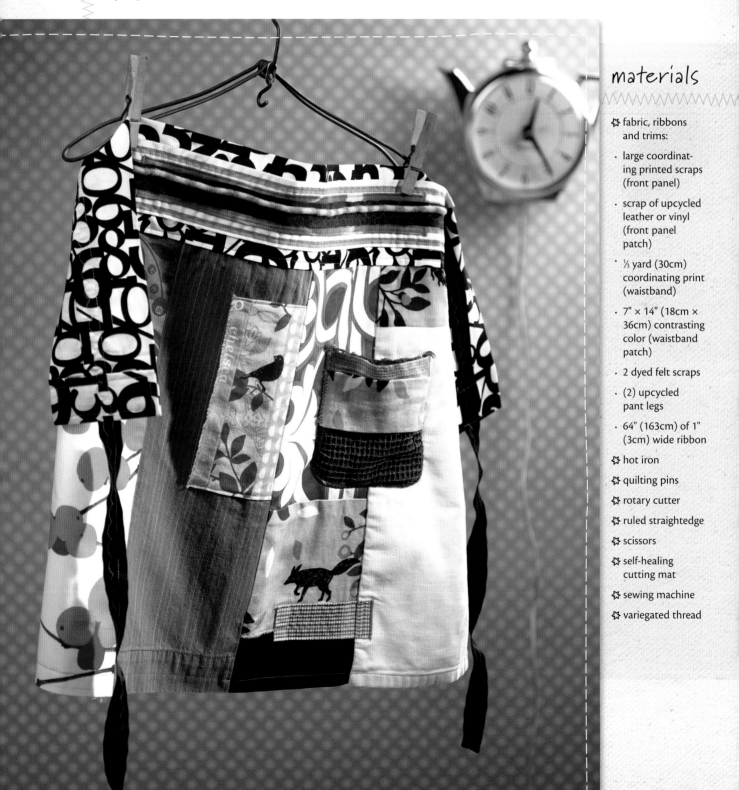

## materials

* fabric, ribbons and trims:
  * large coordinating printed scraps (front panel)
  * scrap of upcycled leather or vinyl (front panel patch)
  * ⅓ yard (30cm) coordinating print (waistband)
  * 7" × 14" (18cm × 36cm) contrasting color (waistband patch)
  * 2 dyed felt scraps
  * (2) upcycled pant legs
  * 64" (163cm) of 1" (3cm) wide ribbon
* hot iron
* quilting pins
* rotary cutter
* ruled straightedge
* scissors
* self-healing cutting mat
* sewing machine
* variegated thread

We're going to start by sewing the left-hand panel, and then work our way across the 4 front panels of the apron from left to right, just like you learned to read a book. The finished front will measure roughly 17" × 21" (43cm × 53cm), and I used a ¼" (6mm) seam allowance throughout. To add even more loveliness, try topstitching everywhere you have pressed open the seams.

1 Grab a piece of print scrap that's roughly 8" × 12" (20cm × 30cm), and fold the bottom edge under ½" (13mm), pressing with a hot iron to hold the seam in place. Lay a smaller print scrap that's roughly 5" × 8" (13cm × 20cm) along the top of this one, right sides together, aligning the left edges. Sew them together along the aligned side and press open. If you have smaller scraps, just keep attaching them until your pieced strip measures 8" × 21" (20cm × 53cm). Turn and press under the left edge ½" (13cm) for a clean edge.

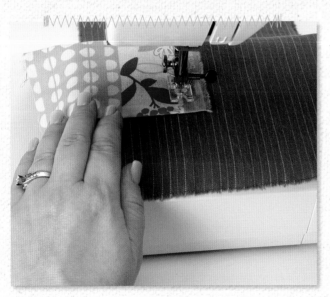

2 Upcycling is a great way to get quality fabrics at a very inexpensive price. For my second panel, I'm using a piece of pant leg from a pair of my daughter's pants that she outgrew long ago. Girls slacks have some really great textures and patterns, and are really easy to find in thrift stores. Cut a rectangle of fabric from the leg of a pair of pants approximately 8" × 21" (20cm × 53cm). To jazz up the pant material, take a small tidbit of scrap print, and overstitch it along the right edge, a couple inches from the top of the panel. Turn and press under the bottom edge ½" (13cm) for a clean edge.

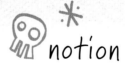 notion

Cut your salvaged pant piece from the bottom part of the pant leg so you can use the hem sewn in by the manufacturer, and save yourself a step.

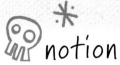

## notion

If you decide to use a material like vinyl, you won't be able to press it open with an iron. The vinyl will melt and ruin your iron! After stitching the vinyl to the fabric, open the seam and topstitch with a zigzag stitch to hold the seam open. This will keep the seam open and flat without needing to iron.

3 Place the first 2 panels right sides together, matching up the bottom edges. Sew them together with a straight stitch along the long edge where they line up. Press open with a hot iron.

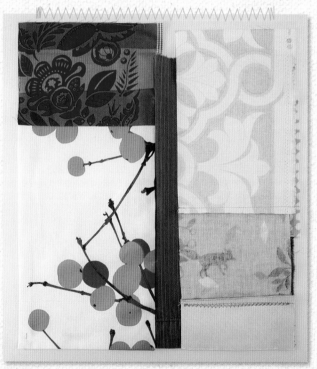

4 Make the third and fourth panels in exactly the same way as the first 2, using another piece of upcycled pant leg (I used a pretty white cordoroy), fabric scraps and using unconventional materials, like vinyl or leather. Iron under a $\frac{1}{2}$" (13mm) hem along the bottom edge of each panel.

5 In the same way you did in step 3, sew all 4 front panels together. Don't worry about the tops of the panels lining up, but make sure the bottoms are evenly aligned. Since you turned under the bottom edges of each panel, you will have a nice, finished bottom edge once the panels are sewn together. You're almost done with this section of your apron.

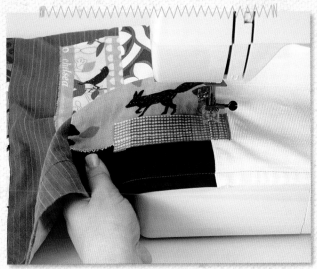

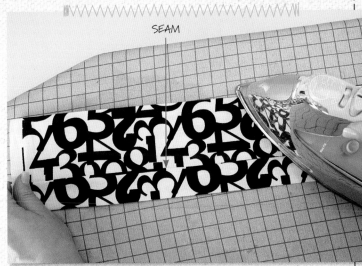

SEAM

6 Sew on more scrap prints by overstitching them in random places on the front panels, using decorative stitches to accent them. Press all seams open, and then iron under a ¹/₂" (13mm) hem along the right side just like you did the left. (If you used a selvedge along this side you can skip this part of Step 6.) Using a contrasting or variegated thread, topstitch down the right side, across the bottom, and up the left side of the front panel. Repeat several times with different color threads and/or decorative stitches. Do not sew in exactly the same place on each pass so you can see each set of your stitches. The front section is complete.

7 It's really simple to make this artsy waist band. Start with ¹/₃ yard (30cm) of print fabric, and fold it in half lengthwise, right sides together. Sew down the open long side, sewing the folded fabric into a long tube. Turn the tube right-side-out, and press the tube flat with a hot iron, making sure that the seam is about 1" (3cm) up from the bottom on the back of the band, as shown.

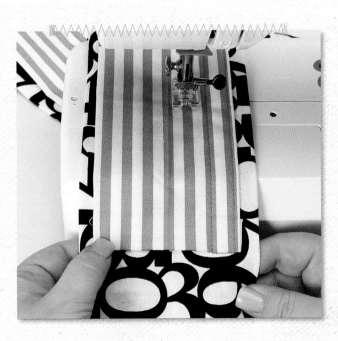

8 Grab your 7" × 14" (18cm × 36cm) contrasting fabric. Turn the top, bottom and side edges under ¹/₂" (13mm) and press. This way, all the raw edges are turned under. Center the strip on the waistband tube. Sew straight lines ¹/₄" (6mm) apart lengthwise across the contrast fabric until it is completely sewn onto the waistband. Repeat by sewing a smaller rectangle of your dyed fabric on top of the contrasting strip. Use a satin stitch around the edges of this last piece for added texture.

 notion

If there's ever a time you don't have enough fabric or don't want to turn under the ends, try satin stitching over the raw edges to secure them.

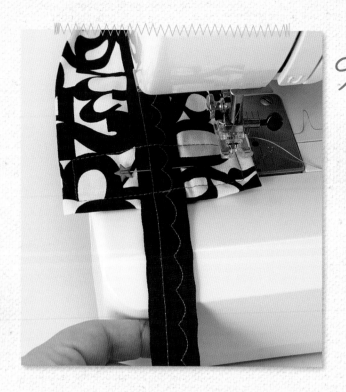

9 Turn both ends of the waistband tube under 1" (3cm), and under 1" (3cm) again to create 3 layers of thickness, and pin to secure. Next, position the 64" (163cm) ribbon across the center of the waistband, keeping even amounts of ribbon coming off both ends. Pin the ribbon in place, and sew a straight stitch along the top edge of the ribbon, attaching the ribbon to the waistband. Remove the pins, and run a decorative stitch down the full length of the ribbon. Finally, stitch a rectangle at each short end of the waistband to further tack down the turned-under ends.

 notion

Stitch felt "worms" or other embellishments to the waist-band by hand if you'd like.

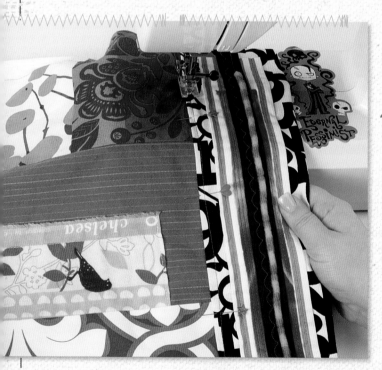

10 Using a rotary cutter and mat, trim the top edge of your paneled apron even with the shortest column so that it's straight. With the right sides of both facing up, lay the waistband on top of the front panel. Overlap the waistband over the apron's top edge about 1" (3cm) so that the raw edges of the apron panel are on the backside of the waistband. Pin together every 3" (8cm), and straight stitch the waistband to the front panel.

 notion

If you want a more finished back to your apron, simply lay your front panel right-side-up on top of a piece of white muslin that's slightly smaller than your fin-ished apron. Straight stitch all the way around the edges of both pieces to join them. Don't worry about the raw edges of the muslin since they won't show through the apron. Make sure to do this before sewing on the waistband.

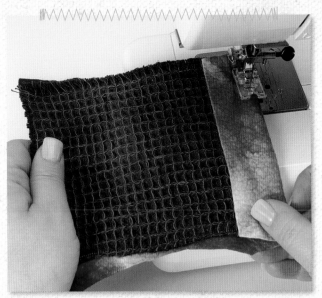

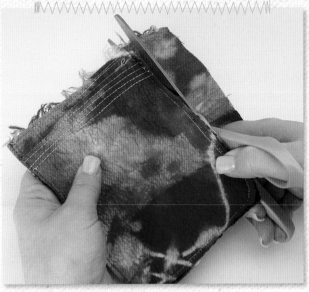

11 To make the pocket, take a 5" (13cm) square of your dyed felt, and place it wrong sides together with a 5" × 7" (13cm × 18cm) piece of contrasting dyed felt. Line them up along one short edge (this is the bottom). Straight stitch the pieces together along the right, bottom and left sides, leaving the top open. As you stitch around the corners, round them slightly so they're not too pointy. Turn the pocket right-sides-out. Fold the top flap down over the front of the pocket, and sew it shut by stitching back and forth several times as with the waistband.

12 You should now have a **sandwich** of textured fabric that is completely sewn shut. Place it right sides together with another dyed scrap that is slightly larger than the pocket. Straight stitch around both sides and the bottom, creating a pocket. Trim any excess fabric away, and turn the pocket right-side-out.

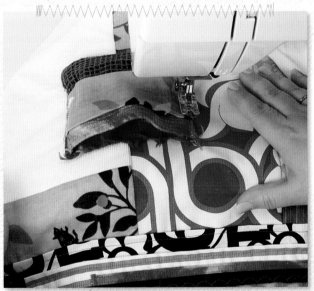

💀 *notion

I wrapped a long scrap of fabric around my pocket before stitching it to the apron. When I stitched the pocket down, I caught the edges of this scrap in the seams. It adds just another bit of fun. Try this with fabric scraps, ribbon, felt "worms" or anything else you think will jazz up your art apron.

13 Last but not least, place your pocket on the front of your apron on whichever side you fancy. Starting at a top corner, sew around 3 sides, leaving the top open. This will create a double pocket that is fully lined. Pretty nifty, huh?! Now that you've pulled it off, there's no excuse for not making more as gifts for all your best girlfriends. Plus, you now have a fun apron to keep you company whenever you cook or create.

# Matryoshka Feedsack Rug

When I was a girl, my grandma had a set of nesting or matryoshka dolls. I distinctly remember sitting on the floor with them, unpacking all the dolls, lining them up along the carpet, and then packing them all back up again. I'm not sure why, but to this day the littlest one that opened was always my favorite. I still love seeing nesting dolls in stores, and can't resist the urge to open them up to see what's inside. Let me tell you, they come in all sorts of themes and sizes from the ridiculously large to the minutely small, and everything in between. This is a quick project that relies heavily on fusible webbing and the satin stitch, not your sewing prowess, and lets your fabrics speak for themselves. This rug isn't meant to be used as your front door rug—the vintage feedsack won't hold up to much shoe abuse. It's more of a decorative rug for your studio or kitchen...maybe even as a housewarming gift for someone special.

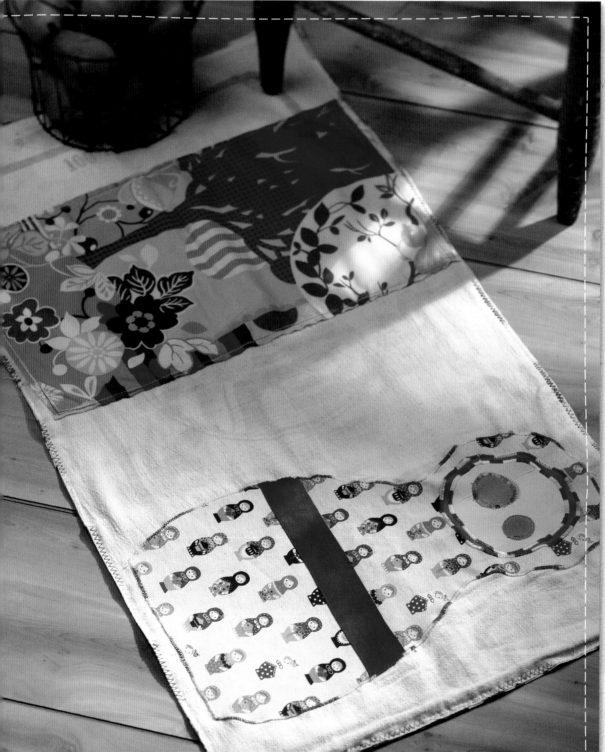

## materials

- fabric, ribbons and trims:
  - top or back half of vintage feedsack
  - 1 yard (91cm) coordinating fabric (side panel/backing)
  - ½ yard (46cm) matryoshka print fabric
  - scrap of dyed red fabric
  - scrap of unbleached muslin
  - scrap of dyed green fabric
  - 9½" (24cm) of 1½" (4cm) wide dyed coordinating cotton ribbon
- hot iron
- ½ yard (46cm) lightweight double-sided fusible webbing
- Nesting Doll Templates (found on page 121)
- quilt pins
- scissors
- sewing machine
- variegated thread

# before you begin

*Using Nesting Doll Templates (page 121):*

✿ From matryoshka print and fusible web,
   cut (1) Nesting Doll Body.

✿ From dyed coordinating fabric and fusible web,
   cut (1) Large Face Circle.

✿ From muslin and fusible web, cut (1) Small Face Circle

✿ From dyed green fabric and fusible web, cut (2) Eye Circles.

✿ Iron fusible webbing pieces to the wrong side of all coordinating
   Nesting Doll fabric pieces.

✿ Iron fusible webbing to the wrong side of the dyed cotton ribbon.

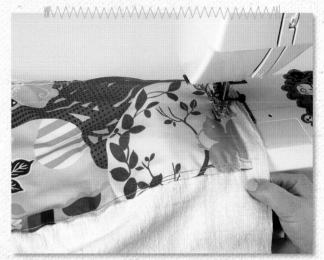

3 Cut a strip of fabric from the coordinating backing fabric that is 10" (25cm) wide and the same height as your feedsack top. Fold under the long sides ½" (13mm), and press with a hot iron. Place the strip on the front of your feedsack, oppposite your matryoshka doll, with the raw edges as the top and bottom. Use a straight or decorative stitch to topstitch it to your feedsack.

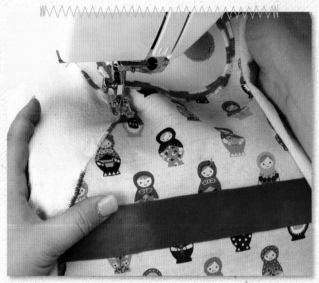

1 Using a hot iron, fuse the nesting doll parts together from the body piece up, removing the paper backing before ironing. Fuse the large face circle to the center of the body's face, the small face circle to the center of the large face circle, and both eyes to the small circle. Fuse the dyed ribbon where the nesting doll would open. Cut the ribbon ends even with the side curves of the doll's body.

2 Peel the backing paper off the nesting doll body piece, and fuse it onto the right-hand side of the top of your feedsack. Satin stitch around the eyes, face pieces, and outside edge of the nesting doll's body using variegated thread. Be sure to catch the ribbon ends in your satin stitch to keep them from fraying.

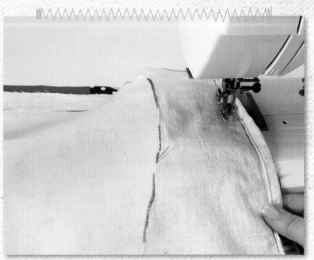

4 Lay the appliquéd feedsack right sides together with the rug backing fabric. Straight stitch around all the outside edges of the feedsack, leaving a small 5" (13cm) opening to turn the rug right-side-out.

5 Turn your rug right-side-out through the hole. Fold the raw edges of the opening down, pin them in place, and press with a hot iron to hold. Starting at the top of the opening, stitch the hole closed. Satin stitch around the perimeter of the rug to finish it up. Now, all you have to do is find it a good place to lie around all night and day!

# Bright Bunting

All of a sudden, it seems as if buntings are everywhere you look on the Internet. I've always admired them, but was never really crazy about the pennant shape. After quite a bit of brainstorming, I came up with the idea of making them in one of my favorite shapes: houses. To add a little more difficulty to this project, I also decided to patchwork-piece them and use up some of my scraps. If houses don't float your boat, use your imagination and come up with another shape. The assembly method is basically the same regardless of what shape you make, so run wild and do something out of left field!

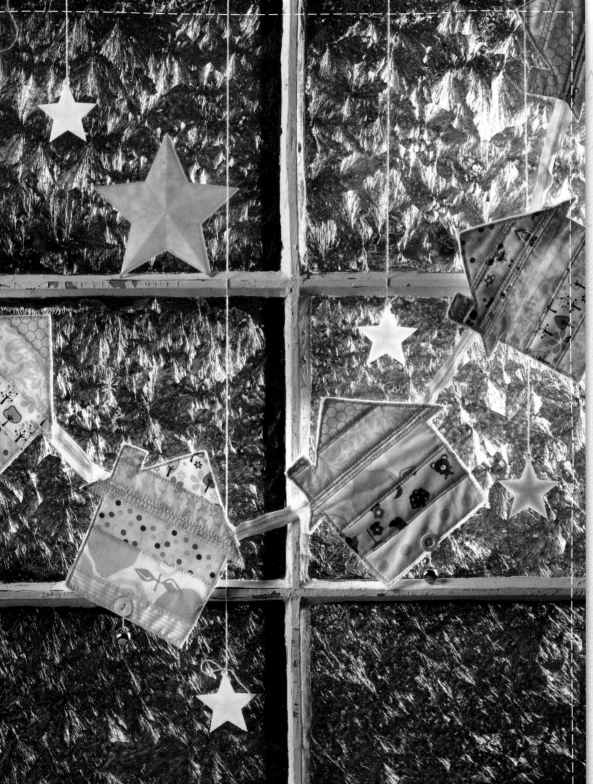

## materials

✿ fabric, ribbons and trims:
- ½ yard (46cm) of dyed fabric (house backings)
- (35) 1" × 6 ½" (3cm × 17cm) strips of fabric (house fronts)
- ½ yard (46cm) quilt batting
- (2) ½-inch (13mm) wide coordinating ribbons, both 40" (102cm) long
- 59" (150cm) of ¼" (6mm) wide velvet coordinating ribbon
- 59" (150cm) of ½" (13mm) wide iridescent coordinating ribbon

✿ (7) antique buttons

✿ cardboard

✿ (7) chipboard stars

✿ hot iron

✿ House Template (found on page 118)

✿ pencil

✿ piece of scrap paper

✿ quilting pins

✿ scissors

✿ sewing machine

✿ sewing needle

✿ (7) small jingle bells

✿ thread

✿ vanishing fabric marker

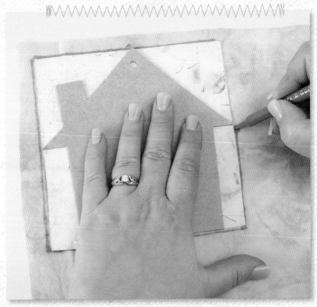

notion

You can make your
houses bigger or
smaller than the
template. Just
enlarge or shrink
the given template.
Keep in mind that
you'll need dif-
ferent amounts of
fabric, batting and
trim if you do this.

1 Scan and print or photocopy the House Template on page
118. Cut out the house shape and trace it onto cardboard.
Cut the house shape out of the cardboard, and lay the
shape on top of a piece of scrap paper. Cut this paper into
a square that your shape fits inside, and use it to cut 7
squares out of your backing fabric and quilt batting. Put
your cardboard template aside for later.

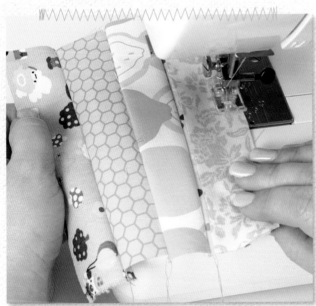

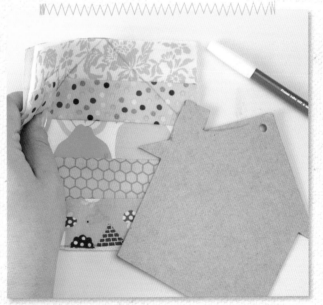

2 To make your quilted house fronts, sew 5 different strips
of fabric together, matching up the long sides until you
have a patchwork panel. Snip off your thread ends, and
press the seams toward the darker fabric using a hot iron.
Make 7 pieced panels in this manner.

3 Make a sandwich by layering a patchworked panel
right-side-up on top, quilt batting in the middle, and
your backing on the bottom, right-side-down. Lay your
cardboard house on top of the pieced panel, making sure
that none of the house is hanging off the edges of the
sandwich and that no sharp corners fall directly onto a
strip seam. Trace around the house using a disappearing
fabric marker. Repeat for all 7 sandwiches.

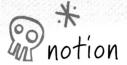

# notion

I used a yellow thread that goes nicely with all of my yellow fabrics, but try using a contrasting or variegated thread to see the outline, and add another decorative touch. Before you cut your threads, tie them in a knot first for added security, and as another embellishment.

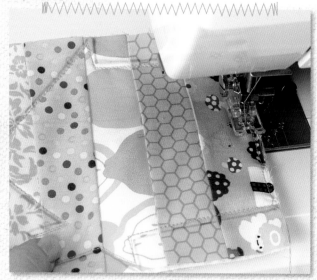

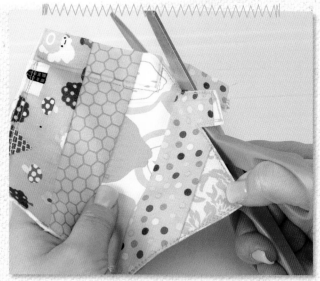

4 Straight stitch through all 3 layers about an ⅛" (3mm) inside the outline of your house. Sew around 2 or 3 times to hide any imperfections. Backstitch at the beginning and end when you sew to keep your thread from pulling out. Do this for all 7 sandwiches.

5 Use a pair of sharp scissors to cut out your shape along the traced line, being careful not to snip through any of the stitches. Sharp scissors will make the edges cleaner, and the sandwich easier to cut through.

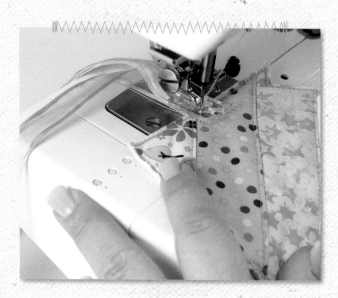

6 Cut the two 40" (102cm) lengths of ribbon in half, to create four 20" (51cm) lengths. Take 1 of each color/design ribbon, fold them in half, and sew to the back right-hand side of 1 house. Do this by setting the zigzag stitch to zero, and sewing in place for a few seconds. Repeat this on the back left-hand side of another house. These houses will be the far ends of your bunting, and the ribbons you just sewed on will be what you use to tie it up. Set these 2 houses aside.

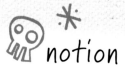

# notion

If you are using ribbons made from synthetic material, keep them from unraveling by singeing both ends with a lighter. Just pass the flame back and forth over the ribbon end until you see it begin to melt and pull in on itself.

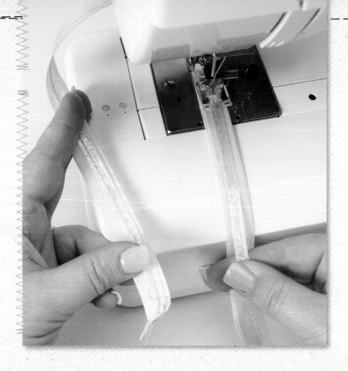

7 Grab your narrow and wide lengths of ribbon. Lay the narrow ribbon on top of the wider one aligned down the center. Stitch the 2 ribbons together, straight-stitching down the center of the narrow ribbon, creating a layered ribbon.

 notion

You can really change the look of your bunting in Step 7. Experiment with complementary vs. contrasting colored ribbon, shiny vs. dull, textured vs. smooth, etc. Another way to further tweak your bunting is to use a decorative stitch or variegated thread to sew the two ribbons together.

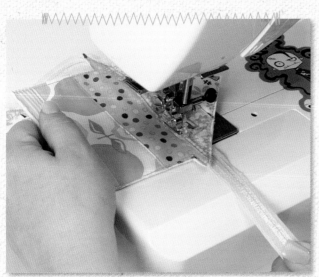

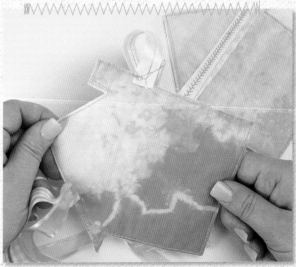

8 Find the middle point of your layered ribbon. This is where you are going to sew your center house. Lay 1 house right-side-up on top of the ribbon at this center point, placing the ribbon about 1/3 of the way down from the top of the house. Pin the house to the ribbon. Sew the house to the ribbon using any decorative stitch you like; sew from the top of the quilt sandwich, not from the backing side. Repeat to attach each house along the ribbon, working from the center house toward the ends. Space the houses out evenly, with approximately 11" (28cm) between the center of every house.

9 Attach the end houses last. Don't sew the layered connecting ribbon all the way across the back of these 2 houses. Instead, zigzag the ribbon to the back inside edge of each end house with a zero stitch length. At this point you officially have a bunting ready to tie up and enjoy, but we're not going to stop just yet. As is common with those of us in the mixed-media world, I like anything I sew to have at least a sprinkle of found objects. Here, I'm using antique bone buttons, chipboard stars, and jingle bells so the banner tinkles when you touch it.

# Leftovers Pot Holder

If you're flipping through this book looking for a quick project to get your creative juices flowing, look no further. This is a fast and fun way to use up all those fabric scraps leftover from other projects, and get your fingers stitching. To make these, I like to use flawed pieces of dyed fabric, felt scraps, pieces of my kids' outgrown pants, and even old dishrags. I think we all neglect ourselves when it comes to our kitchen essentials, but we love to receive them from friends and family. Here's a way to be green and have a little fun at the same time! Remember, don't waste your nice thread on this project...pot holders are just going to get dirty.

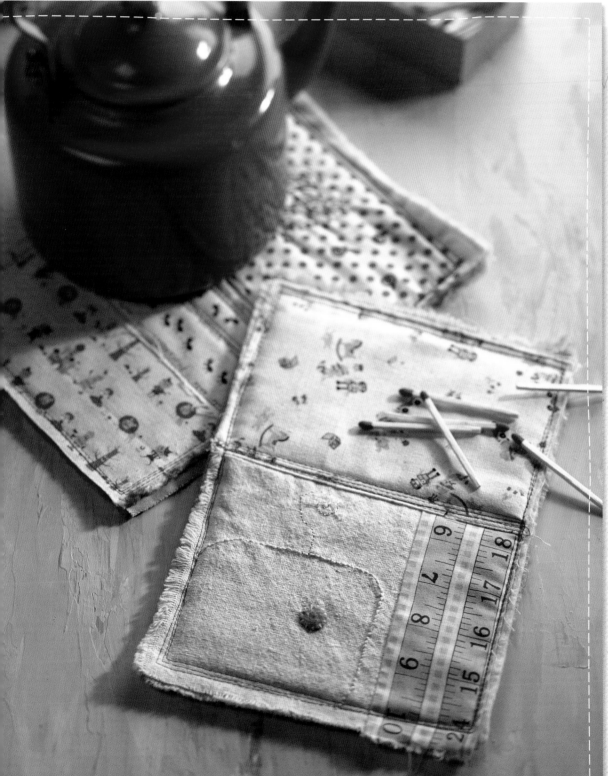

## materials

- ✿ fabric, ribbons and trims:
  - · fabric and felt scraps
  - · 5" × 6" (13cm × 15cm) piece of linen
  - · 6" × 9" (15cm × 23cm) piece of flannel
- ✿ embroidery or tatting thread
- ✿ sewing machine
- ✿ sewing needle
- ✿ thread

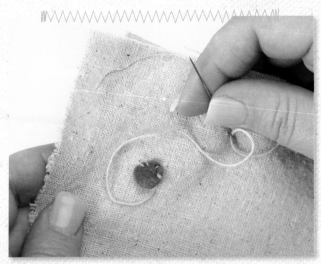

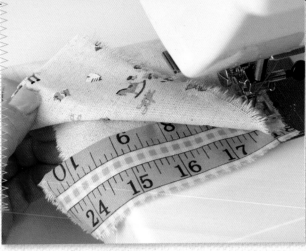

1 Start by collecting your fabric scraps and deciding on a theme or motif. Let your fabrics inspire you. Separate your embroidery thread into 3 strands, or use tatting thread. Embroider the piece of linen with one of your own sketches. I used fabric scraps from a Pinocchio-print fabric, so I embroidered a whale on my linen.

2 Next, sew scraps of fabric to your embroidered linen piece patchwork style. Open all the seams and press them toward the darker or thicker fabric. Keep doing this until you have a pieced rectangle that's approximately 6" × 9" (15cm × 23cm).

notion

Consult pages 24-25 for more detailed directions on how to patchwork-piece your scrap fabrics together into a usable size.

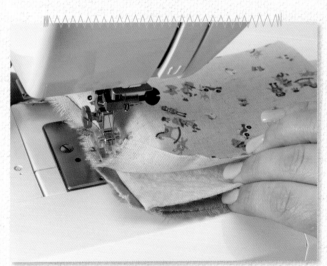

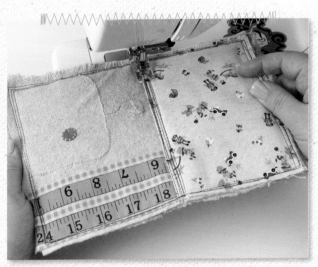

3 To make the pot holder, stack your fabrics together like a sandwich. My bottom layer is a scrap of dyed flannel, then a piece of pant leg on top of that, a piece of felt, and my stitched linen piece on top. Each layer is approximately 6" × 9" (15cm × 23cm), but don't worry about your edges being even. Straight stitch around all 4 sides of your sandwich making sure to catch all 4 layers as you stitch. Stitch around the perimeter 3 times to ensure that it stays together in the wash, and to add some visual texture.

4 Finish up by sewing back and forth about 6 times through the narrow center, from short side to short side. This stitching will help create a natural fold for your pot holder.

# Bluebird-of-Happiness Pincushion

Over the last couple of years, I've noticed that birds seems to be making their way into my home and art. I've loved birds my whole life, but in the past they never really did much for me artwise. That all changed when I met my friend, Melody—she taught me the magic of birds in art, and I've loved incorporating them in my pieces ever since. Hands down, this is my favorite project in the book because I now have my own *Bluebird-of-Happiness* that's functional and fun. I can guarantee that you will love making this pincushion as much as you will enjoy displaying it in your home. Don't be put off by the fact that it's blue—you could easily make any kind of bird by tweaking the colors to match the one in your mind's eye.

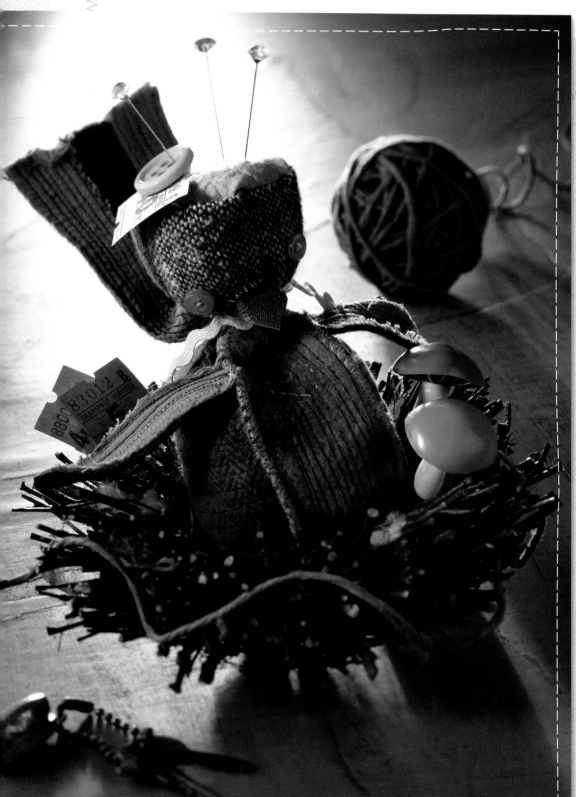

## materials

❀ fabric, ribbons and trims:

- (2) brown tweed scraps (bottom and head)

- turquoise fabric scrap (tail base)

- (3) ¾" × 9" (19mm × 23cm) coordinating blue fabric strips (tail strips)

- 2" × 4" (5cm × 10cm) blue fabric scrap (breast piece)

- (2) 4" × 5½" (10cm × 14cm) brown scraps (body piece)

- aqua fabric scrap (top head circle)

- (4) blue fabric scraps (wings)

- (2) 2¼" × 3¼" (6cm × 8cm) brown scraps (head)

- small scrap of brown leather or vinyl (beak)

- 9" (23cm) narrow blue rickrack

❀ Bluebird Templates (found on page 119)

❀ 2 buttons (small, for eyes)

❀ coarse white/cream thread (i.e. nettle yarn)

❀ red fabric pen

❀ 1 cup (237ml) of sand

❀ scissors

❀ sewing machine

❀ sewing needle

❀ 1 cup (237ml) of stuffing

❀ thread

❀ 2½" (6cm) wooden craft circle

❀ *optional*: white gel pen

1 Place the wood craft circle on a scrap of brown tweed, and trace a circle on to your tweed $^{1}/_{4}$" (6mm) wider than the wooden circle. Using the Bluebird Templates found on page 119, cut a tail base out of a turquoise fabric scrap. Working with the $^{3}/_{4}$" × 9" (19cm × 23cm) coordinating blue fabric strips, lay 1 strip on top of the tail base fabric, and faux felt them together (see page 29). Repeat this process to attach the 2 side strips to the tail base, slightly overlapping the side strips over the middle strip so there are no gaps.

## notion

```
Experiment with the tail shape by not
sewing all the way to the end on 1
strip of the tail. As you faux felt
that strip down, you will notice it
start to curl away from the backing. If
you'd like to use narrower strips, feel
free—you'll just need more!
```

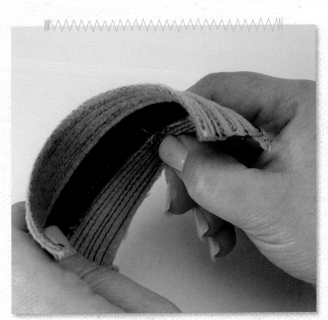

2 Trim any stray edges, and reinforce the curl by pulling your thumb down the length of the tail, like you are curling a birthday ribbon. This will also help rough up your fabric scraps, giving the project more of a handmade look.

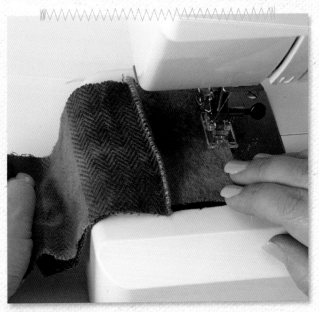

3 Put 1 brown body piece wrong sides together with the blue breast piece, aligning the 4" (10cm) sides. Use a variegated/contrasting thread to satin stitch up and down 1 long side to connect them; sew back and forth until you're sure no sand will be able to escape. This is meant to look rustic, so don't worry about perfection! You want these stitches to be seen. Repeat with the other brown body piece by sewing it to the other side of the breast piece, wrong sides together.

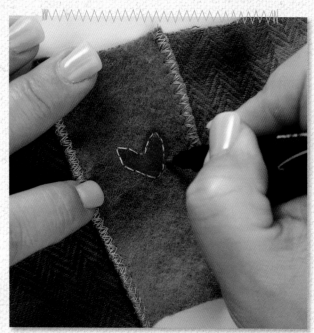

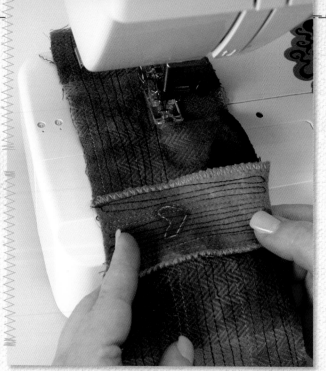

4 Using a coarse thread (I like nettle yarn), stitch a small heart shape onto the center breast piece, approximately 1 1/2" (4cm) up from the bottom and just right of center. Snip your threads and color the heart in with a red fabric pen. Draw a red outline around the outside of your stitches, too. If you color over your stitches by accident, simply go over them with a white gel pen.

5 Using the *Faux Felting* technique (page 29), sew vertical columns up and down the breast piece and horizontal rows on the side pieces with the same thread you used to sew on the tail. Use a short stitch length and sew your columns/rows close together, leaving about 1/8" (3mm) between rows. This stitching is purely decorative!

 notion

```
Anytime you stop to adjust your
fabric, make sure your needle is
down. The needle will help hold
your material in place and keep
it from shifting while you adjust.
```

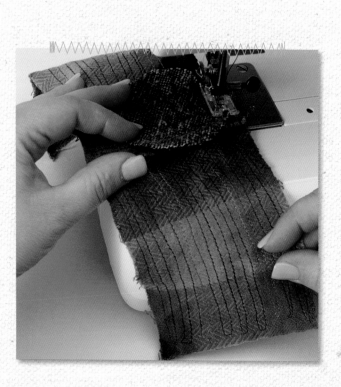

6 Lay the tweed bottom circle in the center of your body piece, right sides together, aligning the edge of the circle with the bottom edge of the body. With a narrow zigzag stitch, begin sewing the bottom edge of the body piece to the edge of the circle. Sew slowly from the center of the breast piece in one direction, easing the fabric around the circle as you sew. Stop once you have sewn halfway around the circle, go back to the center of the breast plate, and continue sewing in the other direction.

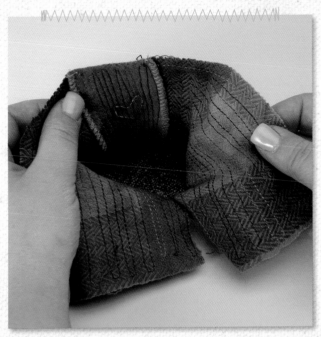

*7* The body will start to curve into a rounder shape as you go. Sew until the body fabric is sewn all the way around the circle. Remove the body from the machine and make sure there are no gaps in the seams for sand to escape. The body will be inside out at this point.

*8* Fold the sewn body in half from the center of the breast fabric to the back point. Holding the breast-piece side in your left hand, squeeze the body flat, and cut the flaps of fabric on your right into an angle sloping up and out from your base circle. This will give the bird body the proper shape to add a tail onto later.

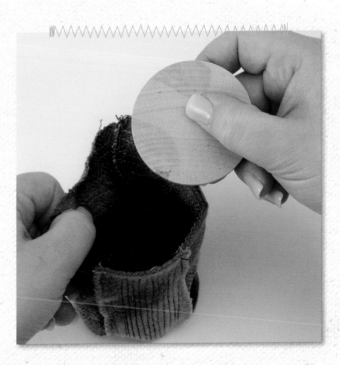

*9* Satin stitch along the angled line you just cut—the stitching won't show so any thread will do. Stitch back and forth several times so the seam is extremely secure. Carefully turn the body right-side-out. Poke out the corners with your fingers and make sure there are no gaps. Push the wooden craft circle into the bottom of the body. It should fit snugly all the way down in the base. Set the body aside.

 notion

If you get to Step 9 and your circle won't fit inside the body section, DON'T PANIC! Just take coarse sandpaper and sand around the circumference of the disc to make it fit.

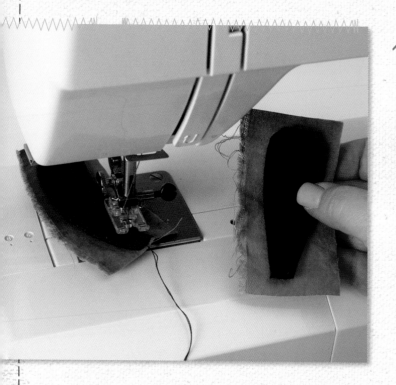

10 Use the Wing Template to cut 2 wings from dark blue felt, and cut 2 slightly larger rectangles from turquoise fabric. Place 1 blue wing on top of the turquoise fabric, wrong sides together. Faux felt (see page 29) the pieces together using blue thread and a short stitch length, slightly following the curve of the wing as you sew. Repeat for the other wing, but flip the blue felt the opposite way so that you have one right and one left wing. Run your thumb over the wings to accentuate the curl, and trim them down to the size of the smaller wing, removing the excess turquoise fabric.

Next, take the right wing, turquoise-side-out, and butt the narrow end up against the right body side seam at a height that looks right to you. Whipstitch the short end of the wing in place until secure, hiding the stitches and knots on the inside of the body. Repeat to sew on the second wing. Phew! Wipe the sweat off your brow, and go refill your coffee cup.

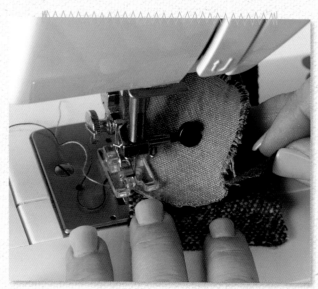

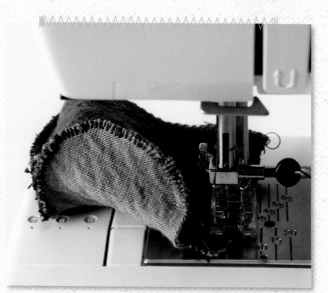

11 Place the 2 brown head rectangles right sides together. Using a tight zigzag stitch, sew together one short side, going back and forth several times until securely closed. This time, the zigzag stitches will be on the inside and your tidy seams on the outside.

Cut out a head circle from the aqua scrap using the Head Circle Template. Place the right side of the head together with the turquoise head circle, and sew them together as you did with the body: Start at the center of the brown fabric rectangle, and sew out in each direction until you have about ¹/₂" (13mm) of unsewn fabric at each end.

12 Zigzag the back seam of the head closed, starting at the open end, and sewing toward the blue circle. You are still sewing with the wrong sides of the head out and right sides in. When you reach the gap you left along the blue circle, finish sewing the head fabric to the circle, closing it all up.

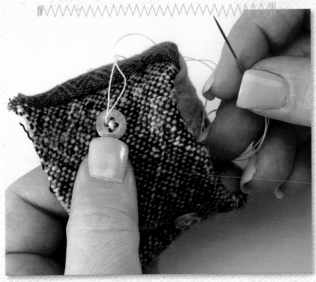

13 Turn the head right-side-out, poking the seam open with your fingers as you go. If you notice any gaps, simply turn it back inside out and restitch until closed. Use a needle and a long piece of coarse white/cream thread to sew on two small blue buttons as the bird's eyes. The eyes should be sewn on about 1/2" (13mm) down from the top of the head, and 1/2" (13mm) in from each side seam.

## ☠ notions

- I like to sew on 2 slightly different size buttons for eyes to make my creatures a little quirky. I'm not talking about a huge difference here, just enough to add a little variety. I recommend using four-hole buttons so you can really attach them well. Your pincushion is going to get lots of wear and tear, and you'd hate for an eye to pop off along the way!

- When sewing on the tail, there are a lot of layers to stitch through, so go back and forth multiple times. Try flipping the entire body over and stitch again from the other side. This helps ensure that the tail's sewn on everywhere, not just what you can see on one side.

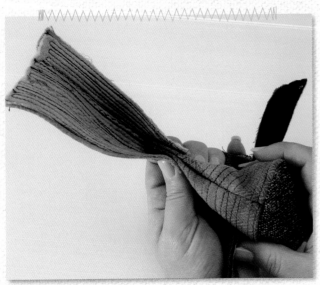

14 Now it's back to the body for a bit. Fold the body in half, right-side-out, and fold the tail in half lengthwise with the striped side up. Sandwich the back body fold into the fold of the tail. Slide the folded edges under your presser foot, and lower the foot to hold everything in place. I'd tell you to pin it in place, but it's really too thick at this point, and too unwieldy to get under your presser foot with the pin so just use your pinchers and keep at it.

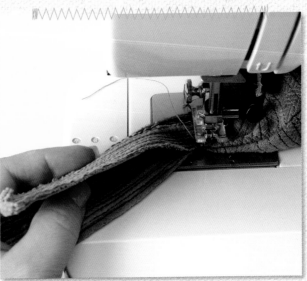

15 Using a matching thread, sew the tail to the body with a tight zigzag. Secure the two parts together by going back and forth multiple times. Start in the middle, and work your way out to the edges, and back in. This is one of the most difficult steps of this whole project, so try not to get discouraged, and definitely don't worry about perfection here! You want to sew just past the edges of the tail onto the body in order to close up the fold at the back of the tail. Once you've got it sewn on really well, use your fingers to open the fold of the tail and bend the end up.

And remember: It's the back end of the bird—just let it go!

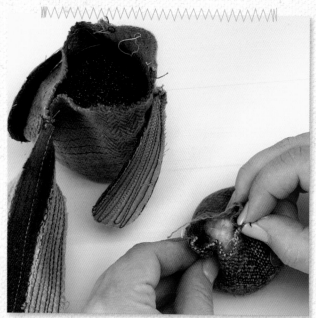

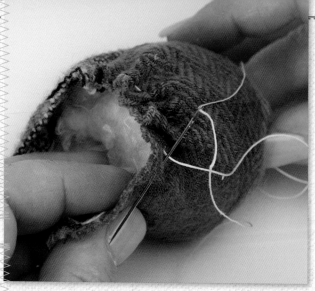

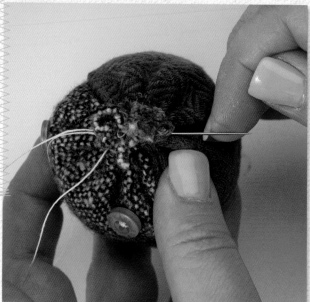

**16** Stuff the head with stuffing and fill the body with about 1 cup (237ml) of sand. Fill both the head and body as full as you can while still being able to pinch the open ends closed. Filling the body with sand does two wonderful things: it makes the base heavy and sturdy so your bird won't keep falling over, and it will sharpen your needles and pins as you stick them into the pincushion. You need to use stuffing in the head so it's lighter and won't flop over at the neck. Collect sand on vacations so you can stuff your pincushions with wonderful memories.

## notion

To sew a running stitch, simply stitch in a line, going in and out of your fabric every ⅛" (3mm) or so. Your fabric will automatically gather a little as you sew, and will do so even more when you pull your thread taut.

**17** Using a really sturdy thread, sew the neck of the head closed, hiding your knots on the inside. Use a wide running stitch starting about ¼" (6mm) down from the opening. Go in and out of the open neck all the way around, pulling the thread snug as you go. When you get back to where you started, pull the thread taut to gather the opening as you close up the hole. Then run stitches back and forth through the entire pucker in an asterisk pattern to really close the neck up tight. When you finish stitching the head closed, *don't* snip your thread ends short—leave them to use later to sew the head onto the body.

Repeat with the open neck hole of the body, starting the running stitch at the tail seam. When you get back to the tail, put your needle in on 1 side and come out on the other. This will gather your body around the tail, and make it sturdier. Tie a secure knot in the fold of the tail, and stitch up through the pucker to hide your thread ends. This time snip the thread ends short. Use your fingers to shape the sand in the body as you sew it up, pushing it around until it looks how you want it to.

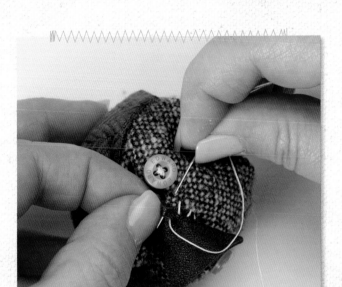

## notion

Rest the head on your thigh
while you stitch on the beak.
This frees your hands up and
gives you more control.

18 Cut a small triangle from the leather scrap using the Bluebird Beak Template. Rethread your needle with the thread hanging from the head piece. Stitch up through the inside of the head, and out through the center where you want the beak to be. Starting in the center of the beak, whipstitch along the top edge to secure it in place, folding the leather triangle into a curved beak shape as you sew. Don't knot your thread when you are finished—stitch back into the head, and down through the neck. Do not snip your threads short.

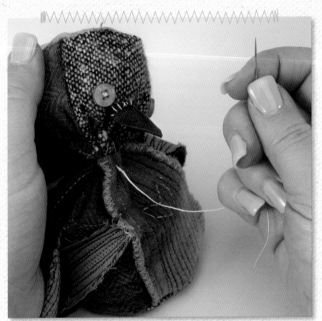

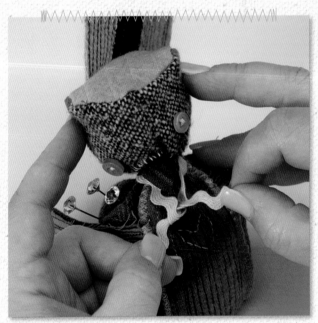

19 Use the remaining thread to attach the head to the body. Hold the two puckers together, and stitch back and forth through both parts until the head is securely attached and doesn't wobble around. Don't worry about stitching pretty, everything will get covered up in the next step. Once you have the head firmly attached to the body, snip your thread short.

20 Tie a small piece of rickrack (or ribbon) around the neck to hide where you connected the head to the body. You now have you own *Bluebird-of-Happiness*. Find a wonderful spot for it in your home or studio, stick in some fancy-schmancy pins, and enjoy!

# Summer Market Bag

Whether it's for art or home, I'm constantly in search of the perfect bag to tote my things around.
When I started writing this book, I still hadn't found it, so I decided to come up with my own design.
This little bag is great for a quick trip to the farmer's market or for toting around your knitting, sew-
ing, journaling or art supplies. To make this bag, I used pieces of all my favorite fat quarters and hand-
dyed fabric bits. I think this is a fantastic way to have your most beloved fabrics with you all the time.
If that seems like too much of a fabric mix for your taste, you can easily make the entire bag from one
yard (91cm) of your favorite print. To make it even more precious and personal, I wrote some of my
favorite words all around and inside. This bag is the perfect marriage of whimsy and practicality!

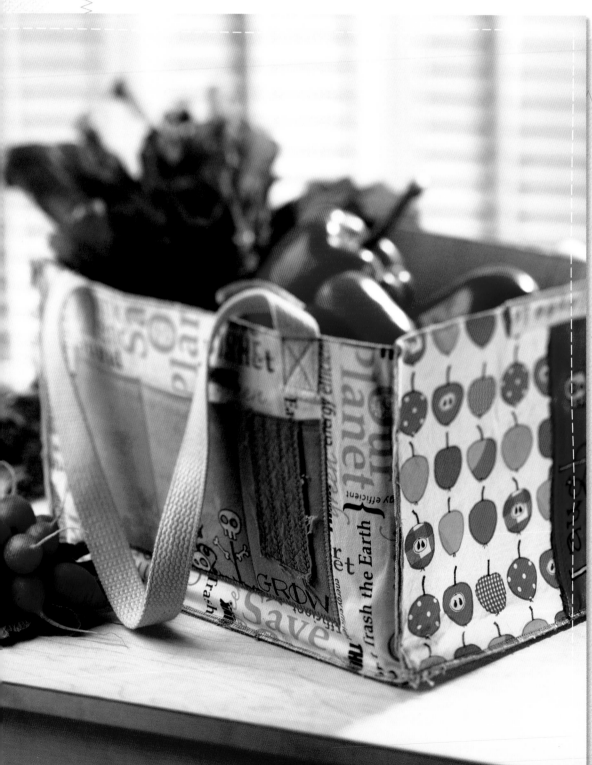

## materials

- ✿ fabric, ribbons
  and trims:

  · 4 coordinating cot-
    ton print fat quarters
    (46cm × 56cm)

  · ½ yard (46cm) can-
    vas/duck/coarse linen

  · 2 coordinating dyed
    fabric fat quarters
    (46cm × 56cm)

  · 48" (122cm) of 1"
    (3cm) wide cotton
    or canvas strap

  · dyed fabric scrap

- ✿ fabric pens
- ✿ hot iron
- ✿ ½ yard (46cm) light-
  weight double-sided
  fusible webbing
- ✿ 1 yard (91cm) medi-
  um to heavyweight
  double-sided fusible
  interfacing
- ✿ quilting pins
- ✿ rotary cutter
- ✿ self-healing
  cutting mat
- ✿ sewing machine
- ✿ 8" × 12" (20cm ×
  30cm) thick card-
  board or woven
  plastic mat
- ✿ variegated thread
- ✿ white gel pen
- ✿ *optional*: decora-
  tive ribbon scraps,
  charms, buttons

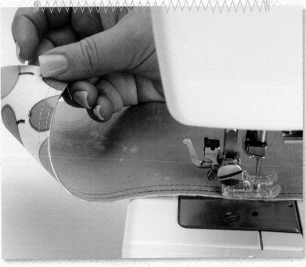

## before you begin

✿ From cotton prints, cut:

· (2) 8" × 12" (20cm × 30cm) rectangle (exterior side panels)

· (2) 8" (20cm) squares (exterior end panels)

· (1) 5" × 8" (13cm × 20cm) rectangle (large pocket interior)

✿ From canvas, cut:

· (2) 8" × 12" (20cm × 30cm) rectangle (interior side panels)

· (2) 8" (20cm) squares (interior end panels)

· (2) 8½" × 12½" (22cm × 32cm) rectangle (bottom pieces)

✿ From dyed pieces, cut:

· (2) 5" × 8" (13cm × 20cm) rectangle (large pocket exterior/ side patch)

· (1) 4" × 8" (10cm × 20cm) rectangles

✿ Iron light fusible webbing to the backs of all dyed fabric pieces. Cool and peel off paper.

✿ Iron medium interfacing to back of all cotton prints as well as one 8½" × 12½" (22cm × 32cm) canvas rectangle.

✿ If your fabric has an orientation, make sure it's going the right way before you sew.

## notion

These stitches not only make your bag sturdy, they also add a decorative touch! If you are a more advanced sewer, try using your favorite decorative stitch here and there to enhance things like pocket tops and make it even more you.

1 Sandwich the cardboard or mesh between the two $8^{1}/_{2}$" × $12^{1}/_{2}$" (22cm × 32cm) canvas rectangle pieces, right-sides-out. Straight stitch around the perimeter using a $^{1}/_{4}$" (6mm) seam allowance, trapping the cardboard/mesh inside the fabric. Place the 5" × 8" (13cm × 20cm) cotton print rectangle wrong sides together with one of the 5" × 8" (13cm × 20cm) dyed fabric rectangles, and fuse together by pressing with a hot iron. Stitch twice along one long side of the 5" × 8" (13cm × 20cm) sandwich using a medium-length straight stitch. This fabric sandwich will become a pocket on the outside of your bag.

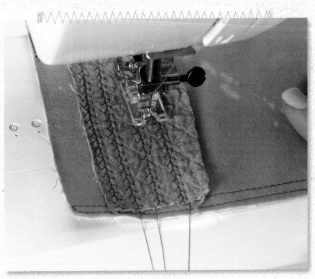

2 Choose a dyed fabric scrap that is slightly darker or is a contrasting color to the dyed fabric from Step 1. If you don't have any scraps, snip and tear one out so that it has frayed edges. Use one of your favorite decorative stitches to sew the scrap onto the dyed fabric side of your pocket. I really like the baseball stitch, but you could use virtually any of them here.

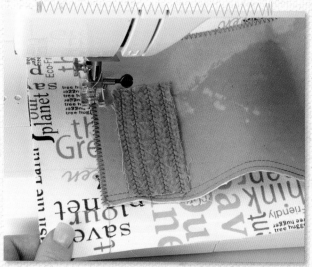

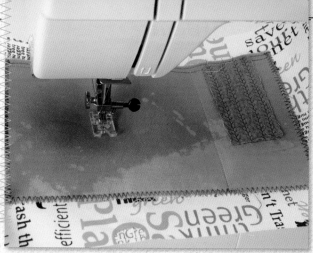

3   Lay the pocket dyed-side-up in the middle of one of the cotton print 8" × 12" (20cm × 30cm) rectangles. This will be one of the long exterior sides of your bag. Starting at the top right corner of the pocket, use variegated thread to stitch a tight zigzag down the side, across the bottom, and up the other side. Turn and zigzag back again over the same 3 sides to where you started. Backstitch at the beginning and end to secure the thread.

4   Split the front pocket into 3 smaller sections by stitching 2 vertical lines a third of the way in from each side of your pocket. Sew 1 stitch past the top and bottom edges, and backstitch at both ends to secure the thread. Trim all threads down to the fabric.

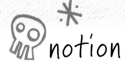 **notion**

When sewing on things like pockets, tie a knot in your thread ends before you cut them. This gives some additional security to your stitches, and it's cute and decorative!

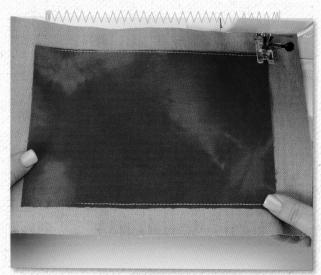

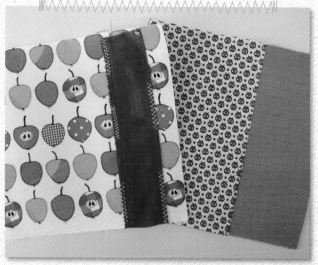

5   Take the other 5" × 8" (13cm × 20cm) dyed fabric rectangle, and fuse it to the center of one 8" × 12" (20cm × 30cm) canvas piece. Use a straight or decorative stitch around all 4 sides to sew it to the canvas. Use a dark fabric pen to write one of your favorite quotes here. Add doodles around the quote to give it even more character. You can use transfer paper if you're worried about making a mistake, or stitch it with embroidery thread instead of just writing it.

6   Continue embellishing the inside and outside panels of your bag using the previous steps. Sew scraps of fabric onto the canvas pieces of your bag, add additional pockets, and doodle to decorate your bag! I added another small pocket to the outside of my bag on one of the short ends. I embellished it with ribbon before sewing the pocket onto the side panel.

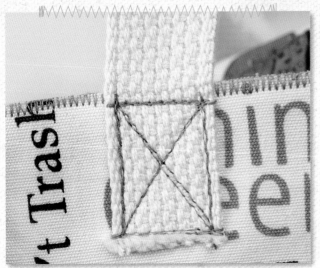

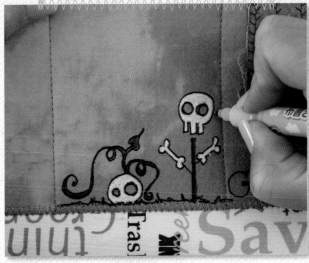

7 Place each interior canvas piece with it's exterior fabric mate, wrong sides together. Pin in place to avoid slippage, and stitch a tight zigzag across the top of all 4 sandwiched sides. Cut your cotton strapping into two 24" (61cm) pieces, and pin each to the outside of a rectangular piece. Each strap-end should be about 2" (5cm) in from the top corners. Sew a rectangle with an **X** through the middle to attach all strap ends to the rectangles. Backstitch every time you turn a corner, and sew over everything twice.

8 Now comes the fun part: use fabric pens and a white gel pen to doodle all over the rest of your market bag! Write inspiring quotes and words on your dyed fabric pieces and make the empty spaces yours!

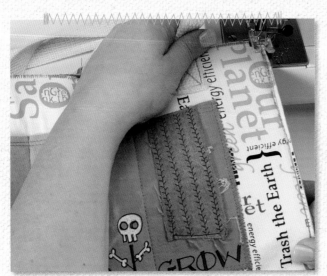

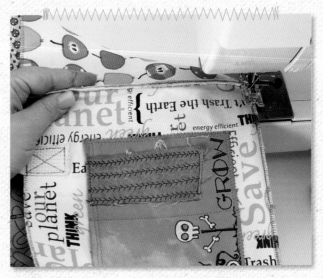

9 Assemble the bag 2 sides at a time. Place a square piece together with a rectangular piece, matching the 8" (20cm) edges, canvas sides together. Straight stitch down the 8" (20cm) side, going back and forth 3 times. Repeat to sew all 4 sides into a box with no top or bottom. Your cut, raw edges will be on the outside of all 4 corners after doing this.

10 To finish up your bag, sew on the bottom canvas sandwich, lining up the bottom edges of the bag with the edges of the base. Starting in 1 corner, straight stitch around the entire base several times making sure the bag is securely attached. Lift your needle out of the fabric at the corners, and ease your bag around the turn. Finish by zigzagging around the entire base to lock in loose ends.

 notion

Sew charms and beads onto your bag in random places, at the edges of your pockets and at the bag corners.

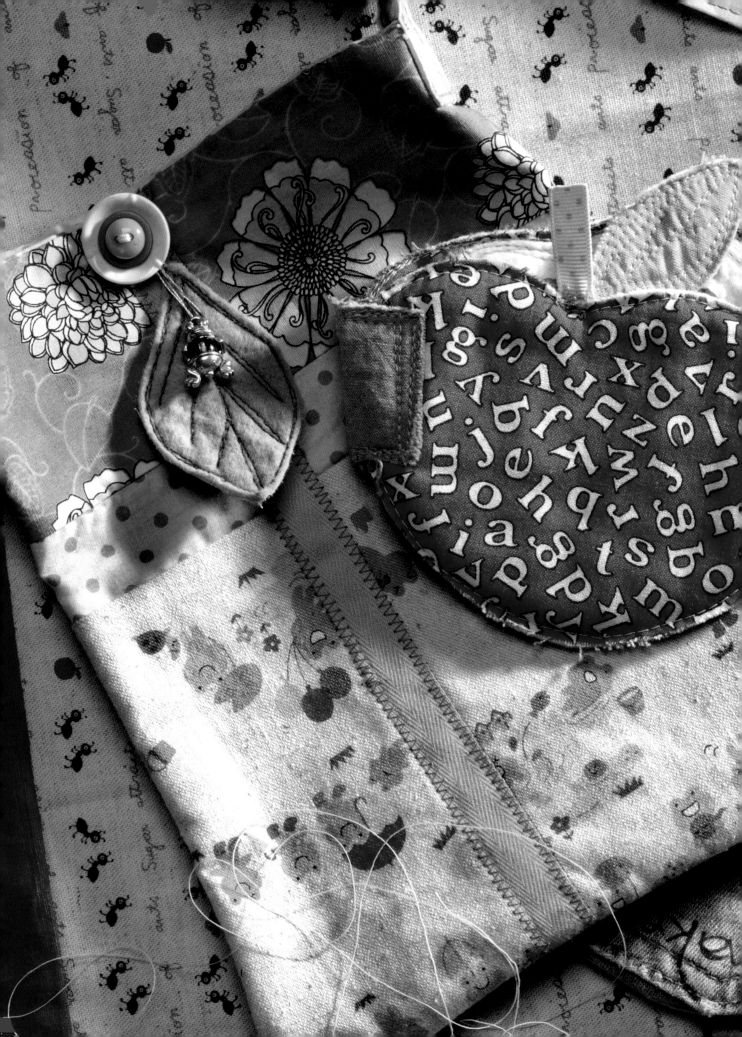

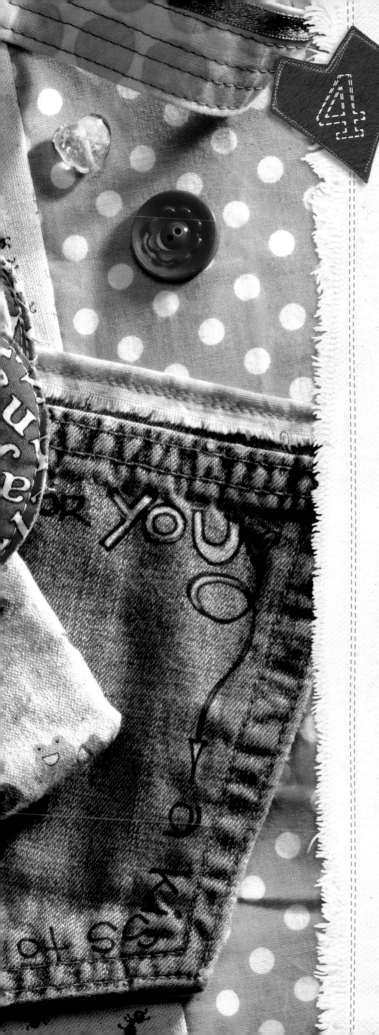

# spread the love

My friend Catherine exclaimed one day while we were chatting that I "sure love a lot of things," and she's right; I'm even guilty of loving love! I love my family, laughing, hugs and kisses, making things with my own two hands, learning and sharing what I know, reading and nature (to name but a few).

But what I really love is to give handmade gifts to my favorite people to show them how important they are to me. I've been stitching up tokens of my affection since I was a little girl, and I created the projects for this chapter in the spirit of that love of giving.

Whether it's for your friends, family or someone you admire, there's something for everyone here: charms to twinkle in the sunlight, pocketfuls of love for someone in need, a peek into a teeny tiny window and something to spiff up a home. If you end up loving something too much to give away, I promise I'll understand! Besides, you can always just make another one!

**love**

noun

- strong affection for another arising out of kinship or personal ties
- affection based on admiration, benevolence, or common interests
- warm attachment, enthusiasm, or devotion

excerpt, *Merriam-Webster's Collegiate Dictionary*, 10th ed., s.v. "Love."

# Sunshine Catchers

There's something about the sun glinting off a shiny object that never fails to put a smile on my face. Maybe it's the magpie in me, or maybe I just love everything bright and shiny. As a child, one day I stumbled upon a tangled heap of colorful wires at a building site. There was something about this huge tumbleweed of color that immediately drew me in. I spent the better part of a year braiding all that wire into bracelets and necklaces, and I've been creating jewelry ever since. I don't usually sell or teach my jewelry projects; I'd rather give it as gifts to those I love, or wear it on special occasions. I share this project with you because it's a wonderful gift for you to give to those *you* love! Spread the sunshine and love around, folks—we could all use a little more.

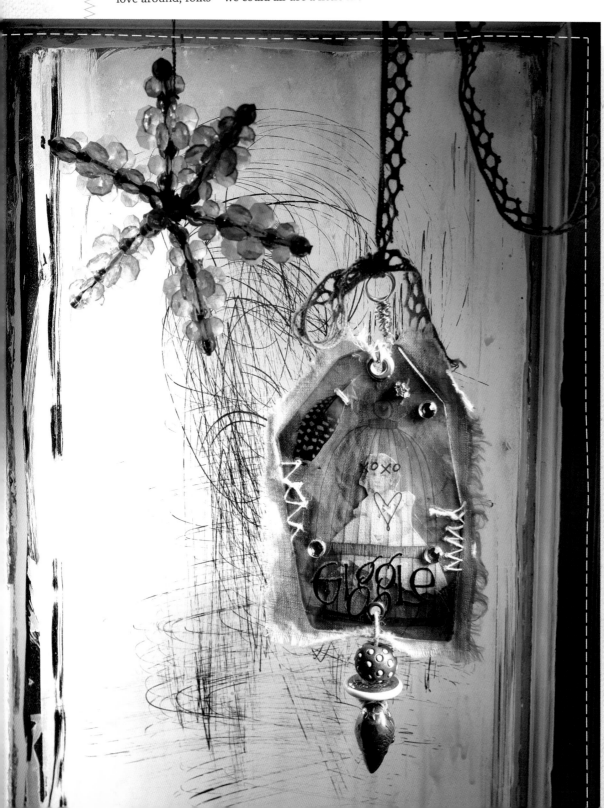

## materials

- ✿ bent nose pliers
- ✿ bird charm
- ✿ craft stick
- ✿ dyed fabric snippet
- ✿ eyelets and eyelet setter
- ✿ fabric pen
- ✿ mica
- ✿ paper piercer or doll needle
- ✿ photo image printed on muslin or paper
- ✿ ring nose pliers
- ✿ round pencil
- ✿ rub-on birdcage by Heidi Grace
- ✿ self-healing cutting mat
- ✿ scissors or craft knife
- ✿ sewing needle
- ✿ small feathers
- ✿ spotted bead
- ✿ thin twine or hemp cord
- ✿ thread
- ✿ 24" (61cm) of 22-gauge (.65mm) wire
- ✿ *optional*: beads, buttons, jewels, additional items for collage

1 Start by cutting your mica chip into a size and shape you like, making sure not to cut it smaller than your largest element (your photo or rub-on, whichever is bigger). Lay the mica on top of your photo so that the element of the photo you want to use is under the mica. Trace around the mica chip directly onto your image.

2 Cut out the image, staying just inside the traced lines so that the photo will fall entirely within the boundary of the mica edges. Using your thumbnail or a dull knife, carefully peel the mica layers apart into 4 pieces. If the layers seem too thick, peel a little more of the layer off. The thinner the layers, the more transparent the mica will appear.

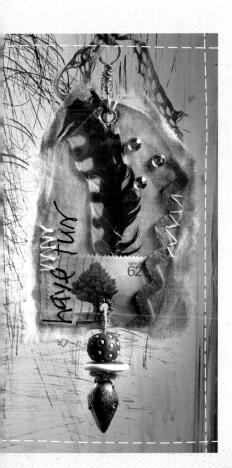

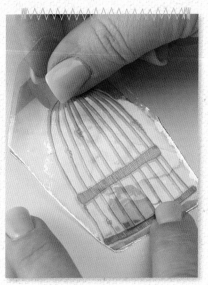

3 Remove the backing paper from the birdcage rub-on and rub it firmly onto one of the mica segments with a craft stick. Gently peel away the transfer paper, checking to make sure the full image has transferred. If part of the image hasn't released, press it back down and rub some more. This is the middle layer of your charm. Set it aside for now.

4 Place the cut out photo under another mica segment. Use the mica layer with the birdcage as a positioning guide by overlaying the birdcage layer.

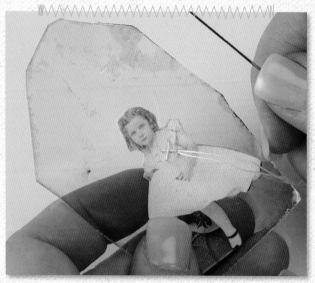

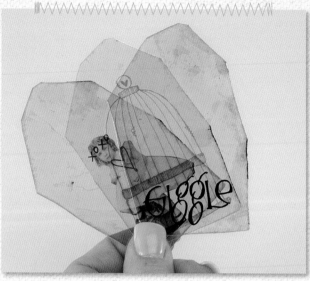

5 Stitch the image to the mica using a sharp needle and thread. Sew up through the image and mica without tying a knot in the thread, and don't pull all the way through. Stitch the photo in place with just a few stitches. (I've sewn my girl in place using an X-stitch over her heart). End with your thread exiting through the back. Remove the needle, and tie a small knot on the back with the 2 pieces of thread.

6 Continue to embellish the topside of your image layers. Be careful not to build the thickness too much or your final charm will be bowed and have gaps. Collage a third mica segment in the same way to use as the top layer of your charm. Stack up the 3 pieces of mica to determine placement of new elements.

## ☠ notions

- Mica scratches very easily so be careful when using anything metal or with sharp edges. If you have a hard time sewing through the mica, pre-poke the holes with a paper piercer.

- Use bright colors of thread and decorative stitches in the interior of the mica to use the stitches as a collage element.

- Use more rub-ons, small feathers, decorative paper, scraps of fabric, ribbons and anything else that strikes your fancy.

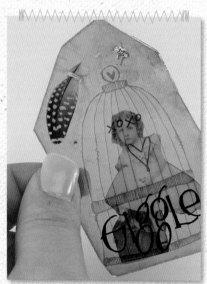

7 Stitch your birdcage and image layers together. Sandwich something like a tiny feather between the 2 middle layers of mica. Just a few simple stitches will hold your layers together. You're going to secure all the layers together later on so just join them a little bit now. Repeat to stitch on the top layer of mica.

8 Cut a piece of your dyed fabric so that it is slightly larger than your pieces of mica. Collage on top of your fabric scrap using the mica as a template for placement. This is your last layer, so stitch down any elements to the fabric using your stitches sparingly. If you are using feathers, clip off the quill to make them flatter.

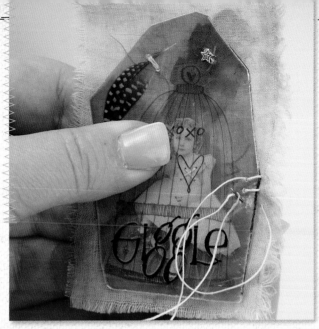

9 Collage the last piece of mica. This is the one that will go on top of the fabric layer, and become the back of your charm.

Sandwich all 4 mica layers together, lining up the edges. Squeeze them together, and sew a few stitches through all 4 layers, leaving your thread unknotted. Whip-stitch around the edges a few times, going down through all four layers, but back up through only the fabric just outside the edge of the mica. (This will keep your fabric from bunching up and moving around.) Finish stitching where you started, and tie your thread ends together. Make sure you sew tight enough to join all your layers together, but not so tight that you can't accommodate the thickness of your interior elements and leave huge gaps.

## notions

- You can use your sewing machine if you'd like, but you'll pay a price. The presser foot tends to push the mica down into the feed dogs, which can leave indentations on the underside of the mica. If you do use your machine, use a wide stitch and try using the hand crank to move your needle instead of the presser foot.

- If you use letters or words in your piece, try orienting them vertically or upside down to create visual interest, like a Seek & Find.

- If you're having trouble stitching through the mica, use a stapler—it will add some interesting texture and is much easier than needle and thread!

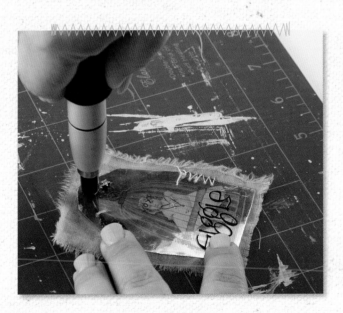

10 Make sure all the edges in your stack of mica line up really well. Working on top of a cutting mat, use a paper drill or hand drill to punch an eyelet hole through the top middle of the charm. You may have to punch several times to get all the way through your layers, so be patient. Stay far enough away from the edges that you don't cut into the edge. Once you're sure that you've gone through all of the layers, choose an eyelet that goes with your color scheme and set it with an eyelet setting tool.

## ✳ notions

- You can buy mica online via scrapbook stores and scientific supply companies, or directly from many mixed-media artists at art gatherings or local scrapbook stores.

- I shied away from eyelets for years because I couldn't set them right to save my life. A couple years ago I discovered a Making Memories setting kit that changed all that. What's unique about this specific brand is that the setting tool has a flower shape on the end instead of just a circle, which breaks the eyelet up evenly. I highly recommend it, especially if you're afraid of eyelets like I was.

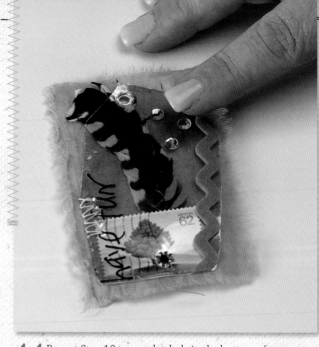

11 Repeat Step 10 to punch a hole in the bottom of your charm. Sew any gaps closed using a needle and thread, and a minimal number of stitches. Use your knots decoratively to add texture, or hide them. Embellish the outside of the charm with anything you like—more stitches, gems, ribbons, etc.

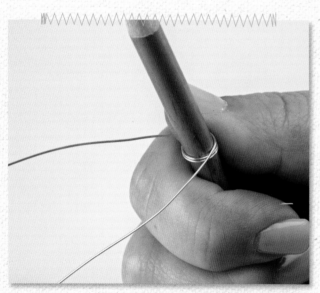

12 Now, make the hanging part of the charm out of wire. I've used 22 gauge (.65mm) silver wire, but if you like something heavier just swap it out. Begin by working 4" (10cm) in from one end of your wire. Wrap the wire clockwise around a round pencil 3 times, securing it with your thumb as you go so that your wire ends in the same place you started.

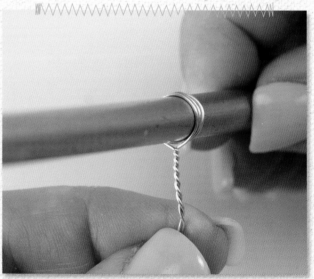

13 Holding both loose ends together tightly, wind the pencil in a circle over and over again to wrap the wire around itself. Take the longer end of the wire, and wrap it back on itself up towards the pencil. Once you wrap it all the way up to the pencil, pull the wire snug and wrap it 3 more times around very tightly to secure it. Wrap the leftover long end loosely around all your twists making a messy twist. Snip off the end and tuck the point down into your twist with a pair of bent nose pliers.

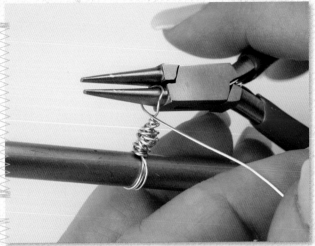

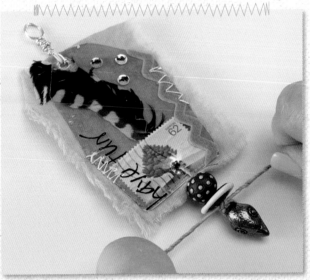

**15** Leave the pencil in your top loop while you attach the charms. Thread 2" (5cm) of a thin twine or hemp cord through the bottom eyelet, and then feed both ends through all of your charms and buttons. Create a big knot at the bottom of the last charm to hold all of them on the cord. Trim any extra cord or leave it a little longer if you like that look better. Slowly pull the pencil out of your top loop, being careful not to crush or bend it as you go.

**14** Create a second loop in the shorter end of your wire by using your ring nose pliers. Before you close up the hole, thread your mica charm onto the wire, making sure it hangs nicely from the loop. To close your loop up, repeat Step 13. Cut the wire short, and tuck the pointed end in with pliers just like before.

## important notion

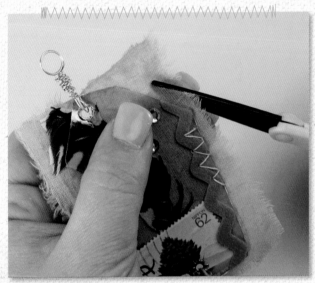

**16** Trim the fabric down to any shape you like, or flush with the edges of the mica. Be careful not to cut through any of your stitches or you'll have to re-sew them. Fray the exposed edges that you've trimmed to give your charm a worn look.

# Pocketful of Love

I've always loved sending and receiving mail, so I was totally swept away many years ago into the world of mail art. I love stitching up little fabric notes, adding one of my quirky vintage photos and finishing it off with a handwritten message. For this project, stitch up a fabric apple with a *kiss-to-make-it-better* hidden inside, and then tuck it into an old pocket to give to someone who needs a little love.

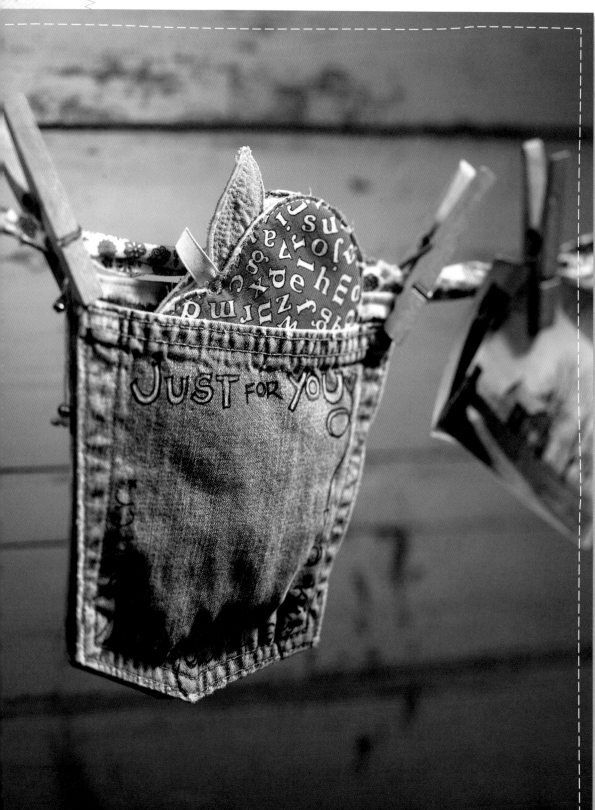

## materials

✿ fabric, ribbons and trims:

- 1 pair of denim jeans with back pockets

- fat quarter (46cm × 56cm) of red fabric

- medium-size piece of green dyed fabric

- 4 green textured fabric scraps

- 3" × 4" (8cm × 10cm) rectangle of raw canvas or duck-cloth

- scrap of novelty or designer fabric

- 2" (5cm) of ¼" (6mm) wide green ribbon

- ⅓ yard (30cm) bamboo quilt batting (prewashed)

✿ Apple Templates (found on page 118)

✿ brown embroidery floss

✿ (1) button (flat)

✿ embroidery needle

✿ fabric pens (variety)

✿ scissors

✿ sewing machine

✿ small photograph printed on fabric

✿ variegated green thread

✿ white gel pen with broad tip

✿ *optional*: small charm and/or bead

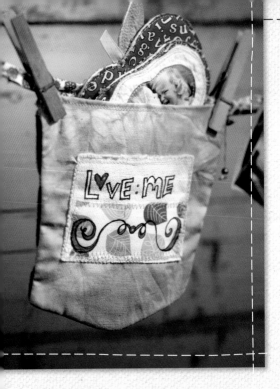

1 Take an old pair of jeans and cut out the back pockets leaving a ¹/₂" (13mm) seam allowance along the top, and ¹/₄" (6mm) around the other 3 sides. Put 1 pocket aside for a rainy day when you have time to make another love note.

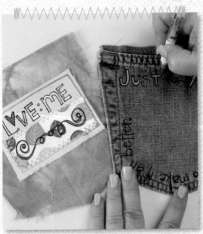

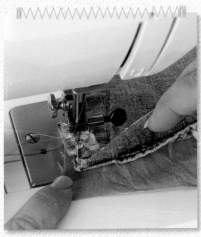

2 Grab a fun green piece from your dyed fabric stash, and cut it out so it's the same size and shape as the pocket. Attach a rectangular scrap of canvas on the right side of the dyed fabric piece by straight stitching around the edges several times. Cut out a coordinating scrap of fabric, approximately half the height of the canvas. Zigzag stitch around it to attach it to the bottom half of the canvas piece.

3 Using fabric pens and a white gel pen, write a short message on the front of the denim pocket just inside the stitching. Let the message wrap all the way around the pocket. Then sign the small canvas patch in the same way you would a letter. Accent the lettering with whimsical doodles, hearts and arrows. Try using the black pen to outline and the colored and white gel pens to fill in and add highlights.

4 Place the denim and dyed pockets right sides together with the denim pocket on top. Sew just outside of the actual pocket so when you turn it right-side-out you can see the entire pocket. Start ¹/₄" (6mm) in from the top right corner of the pocket and straight stitch along the outside of the pocket, stopping ¹/₄" (6mm) from the top left corner. Rotate the pocket and sew back along the same line, stopping where you started.

## notion

Use as many coats of the pen as you want to get the right depth of color. Just let the pen dry in between coats. Try building layers by alternating the white gel pen with colors to create additional depth. The white pen will soften the colors, giving them a chalky appearance, and will help to erase any mistakes you have made.

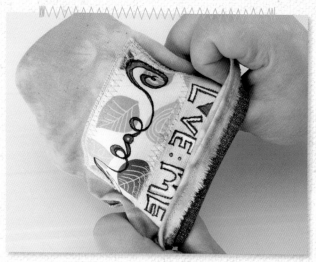

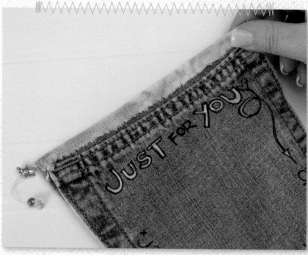

5 Take the pocket out from the sewing machine and trim the threads. Trim the sides and bottom of the dyed fabric even with the edge of the denim pocket. Do not trim along the top edge—you will need the extra fabric there. Turn the pocket right-side-out through the open top.

6 Fold the top of the dyed fabric down over the raw edge of the denim and straight stitch across the edge to attach. Be careful not to sew the pocket shut. Sew back and forth a few times, ending where you started. Don't cut the thread ends short when you finish—use them to tie on a charm or bead that relates to your note. Set aside the completed pocket.

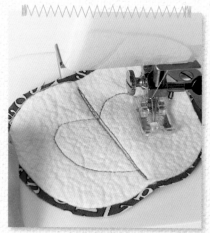

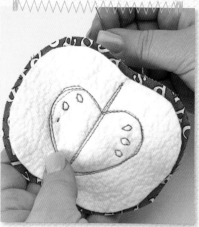

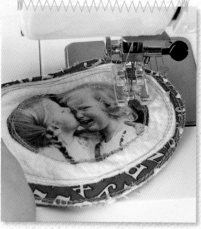

7 Using the Apple Templates (see page 118), cut out 4 apple outsides from the red fabric and 2 from the quilt batting. Cut out 2 apple cores from the batting. Stack an apple core batting piece on top of the right side of 1 red apple outside piece. Using a green variegated thread, stitch down the middle of the apple core, starting and stopping just inside the white edge. Turn and stitch this center line 2 more times, but not right on top of the previous stitches. Sew a heart shape about 1/2" (13mm) inside the core batting to illustrate the pith part of the apple core. Stitch around 3 times. This is the left apple half.

8 Take the left apple half out from the sewing machine. Using 2 strands of brown embroidery floss, hand-stitch 6 ovals in the curved parts of the heart-shaped core. These will be the apple seeds. Knot the thread on the back side of the apple piece so it's hidden once everything is sewn together.

9 Make the inside of the right apple half by repeating Step 7, but stop when you have sewn the center line down the core batting. Take a photo printed on inkjet fabric or muslin, and cut out a shape similar to the apple core but slightly smaller. Sew the photo onto the core of the right apple half, stitching all the way around the photo edge.

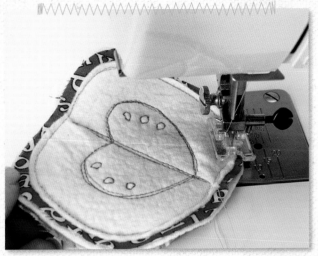

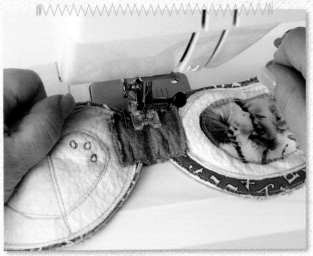

10 Now assemble the apple halves. Stack the embroidered apple piece on top of an apple outside batting piece, and then on top of an outside red piece (right-sides-out). Stitch around the outside edge of the white core piece several times. Be careful not to stitch on top of your previous stitches—go wild and crazy like you did when you were coloring as a child! Repeat with the photo side of the apple to create 2 quilted apple halves.

11 Now, join the halves together so they open and close like a book. Cut two 1½" × 2" (4cm × 5cm) rectangles from a piece of green textured fabric. Place the 2 apple halves next to each other with core sides up about ½" (13mm) apart. Pin the green rectangles onto the apple halves placing 1 on top and 1 on bottom, wrong sides together. It should look like you are building a bridge between the 2 apple halves. Straight stitch down the middle of the squares and then sew around the outside edge of the squares several times.

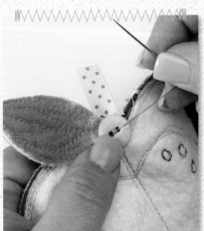

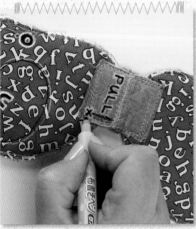

12 It's time to make a leaf to add another something-special! Start by stacking two 4" × 3" (10cm × 8cm) rectangles of green textured fabric right-sides-out with a piece of batting in the middle. Follow the steps in the *Sew Simple Shapes* section (see page 28) to stitch a leaf on the fabric sandwich. Trim about an ⅛" (3mm) outside of the stitch outline to finish.

13 To make the stem of the apple, cut a 1" (3cm) piece of green ribbon. Place the leaf on top of the stem and hand-stitch them down to the inner left side of the apple so that the knot is on top of the leaf. Then sew a button on top of the leaf so the knot and stitches are hidden.

14 Using fabric pens and a white gel pen, write on the outside of the apple. Here, I've written **open** on the outside of the book and **pull** on the green binding piece—the binding will stick out of the pocket and help build anticipation for your note!

# Out-and-About Purse

Like most women I have a thing for purses, but I hate carrying a honking-huge one around with me when I'm just out running a quick errand. For the longest time, my solution to this dilemma was to leave my purse at home, and just carry the essentials in my hot little hands. After making numerous runs to yoga classes, the market or school without a cell phone or lip balm, I decided that my method wasn't working. So, I came up with this pretty little bag that's small enough to grab on your way out the door, but still big enough to hold the things you need most. You could even make up a few of these in different colors to suite any mood by simply changing the fabrics to match the occasion.

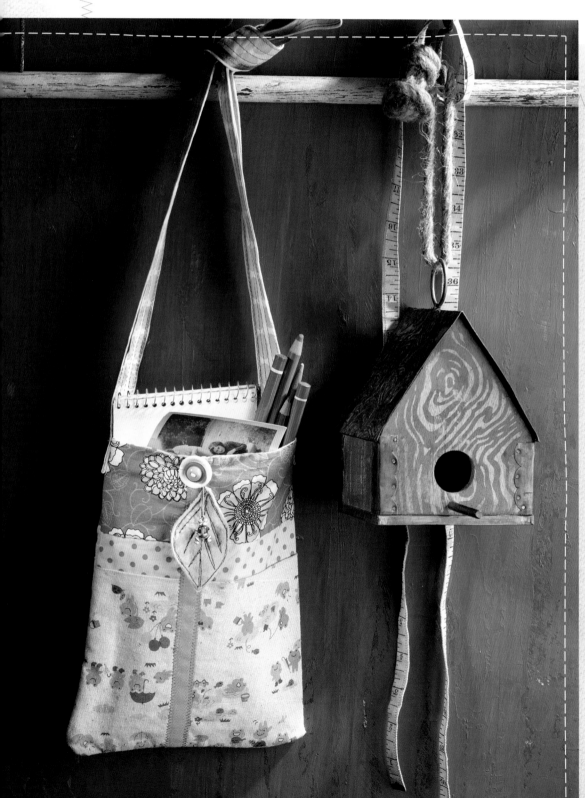

## materials

✿ fabric, ribbons and trims:

- 4" × WOF* (10cm × WOF*) strip of large polka dot fabric (strap)

- fat quarter (46cm × 56cm) of print fabric (bag bottom section)

- fat quarter (46cm × 56cm) of small polka dot fabric (bag center section)

- fat quarter (46cm × 56cm) of floral fabric (bag top section)

- 11" × 15" (28cm × 38cm) rectangle of coordinating dyed fabric (lining)

- 44" (112cm) of ¼" (6mm) wide coordinating ribbon (strap)

- 12" (30cm) of ½" (13mm) wide coordinating cotton twill ribbon

✿ fabric leaf (instructions found on page 28)

✿ hot iron

✿ measuring tape

✿ pins

✿ scissors

✿ sewing machine

✿ sewing needle

✿ thread

✿ vintage buttons, charm and/or glass bead

✿ *WOF=Width of fabric from selvage to selvage should measure approximately 40" (102cm)

## before you begin

✿ From print fabric, cut:
- (1) 7" × 15" (18cm × 38cm) rectangle

✿ From small polka dot fabric, cut:
- (1) 1½" × 15" (4cm × 38cm) rectangle

✿ From floral fabric, cut:
- (1) 3" × 15" (8cm × 38cm) rectangle

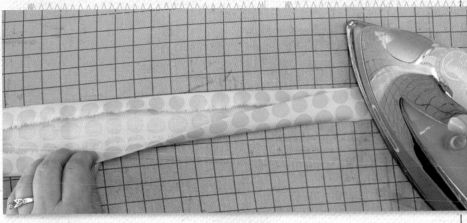

1 Start by creating the purse strap. Press the large polka dot strip in half lengthwise with a hot iron, wrong sides together. Open back up, and press the long raw edges in towards your fold about ½" (13mm). Finish by folding the strap back in half lengthwise, and pressing with a hot iron a final time.

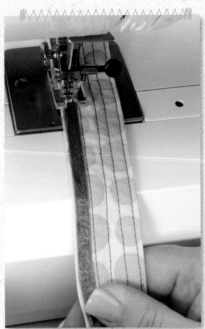

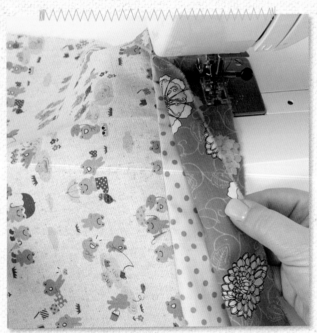

2 Lay the ¼" (6mm) ribbon on top of the polka dot strap, along the open edge. Pin and stitch in place down the center of the ribbon. This not only attaches the ribbon to the strap, it also sews the strap closed. Continue to sew down the length of the strap every ¼" (6mm) until you have rows running down the length of the strap. (These rows of stitches are decorative, but they also help stabilize your strap.) Set the strap aside while you sew the body of the purse.

3 Lay the small polka dot rectangle on top of the print rectangle, right sides together, lining up the 15" (38cm) edges. Sew along one 15" (38cm) side using a ¼" (6mm) seam allowance. Press the seam open with a hot iron, and repeat to sew the flower fabric rectangle to the other side of the small polka dot section. Press the seams open with a hot iron and set aside.

 notion

If your fabric has an orientation, make sure you sew it on correctly to keep the orientation correct in the finished purse. Refer to the project photo on page 90 for help.

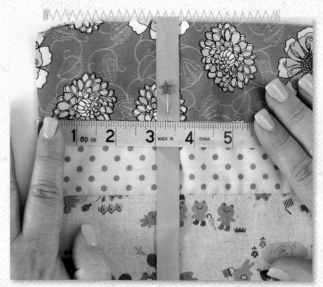

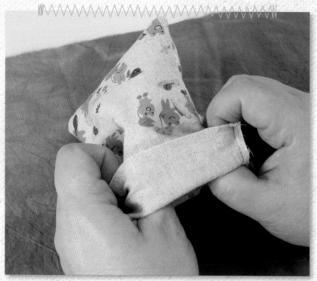

4 Pin the twill ribbon down the length of your purse front, lining up the left side of the ribbon 3" (8cm) from the left edge of the panel. Sew down both long sides of ribbon with a zigzag stitch to attach it firmly to your purse. You can use a decorative stitch or two instead if you're feeling daring!

5 Cut a 4¹/₂" × 6" (11cm × 15cm) rectangle from 2 of your fabrics to make the inside pocket. Place these rectangles right sides together. Sew along the 2 long sides and bottom, leaving the top open. Trim your seam allowance closer to the stitch line. Turn the pocket right-side-out through the hole.

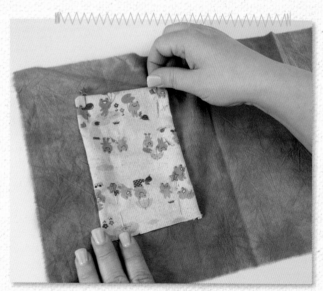

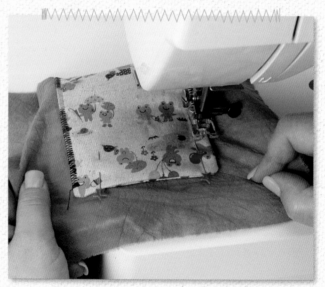

6 Fold under the raw edges of pocket's turning hole, and press with a hot iron to secure. Center the pocket, right-side-up, on the left half of the lining fabric rectangle. The pocket's turning hole should be at the bottom. Pin the pocket in place.

7 Use a very tight zigzag stitch to sew around the sides and bottom of your pocket to attach it to the purse lining. Start and stop sewing ¹/₄" (6mm) from the top of the pocket, and zigzag using a zero stitch length to secure. (Not stitching all the way to edge allows you to get in and out of the pocket more easily.)

 notion

Make sure your pocket edge is riding down the middle of your presser foot opening so the zigzag goes beyond the pocket, grabbing the lining and covering the pocket's edge.

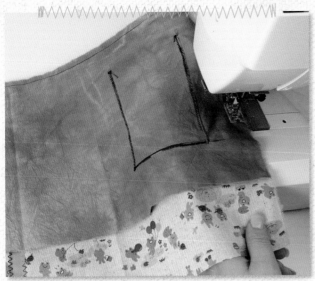

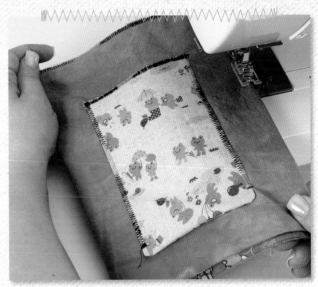

*8* Place the lining panel on top of the outside panel, right sides together, lining up the top and side edges. Make sure that your pocket opening is facing up before sewing. Sew these 2 pieces together along the 2 sides and the top, leaving the bottom open to turn everything through.

*9* Turn the purse right-side-out through the bottom hole, and trim the bottom edge so it is straight. Press the sides and corners flat with a hot iron. Then, fold the purse in half lengthwise so that the lining side is out. Satin stitch around the open side and bottom to close up your purse.

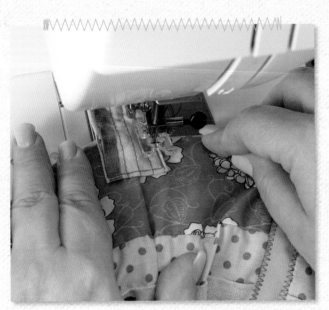

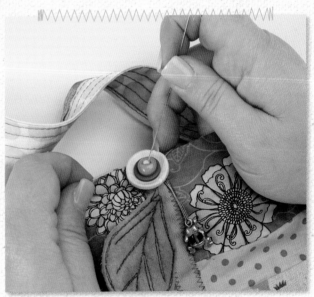

*10* Turn the bag right-side-out. Turn the ends of the strap under about 1" (3cm), and pin the ends to the sides of the bag with the raw edges trapped between the strap and purse. The strap end should overlap the top of the purse by about 1" (3cm). Attach the strap by straight stitching along the sides and bottom of the strap ends, going over the same stitches multiple times.

*11* Use a needle and thread to sew vintage buttons (I stacked 3 on top of each other), a fabric leaf (see *Sew Simple Shapes* on page 28), and a charm at the top of the twill ribbon. Now you're done and ready to be back on-the-go!

# Twinkling Trinket Box

When I was a child, one of my favorite winter stories was *The Little Match Girl*. Something about lighting match after flickering match to see in the shop window captured my imagination. Those are the thoughts that stayed with me as I created my window boxes. Tiny things make me want to stoop down and take a closer peek, so I combined two of the things I love—tiny items and vintage transparency images—into one little flickering box of intrigue. By filling your twinkling box with keepsakes from your own stash, you will create your own magical window to peek inside.

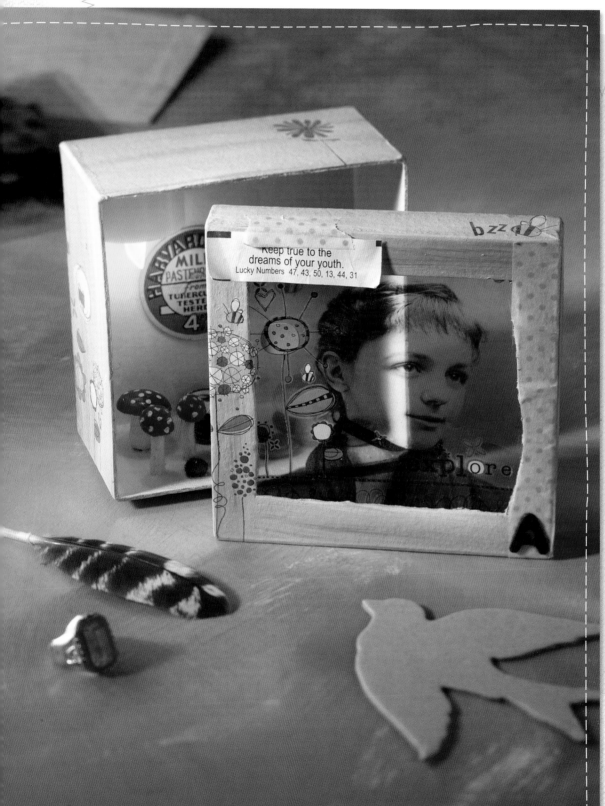

## materials

- ✿ acrylic paint: white, sky blue and bright blue
- ✿ 1" (3cm) button (utility, not decorative)
- ✿ craft glue or adhesive dots
- ✿ craft knife
- ✿ craft paint: white
- ✿ duct tape
- ✿ electric tea light
- ✿ fortune (from fortune cookie)
- ✿ Japanese washi paper tape
- ✿ paintbrush
- ✿ paper or Styrofoam plate
- ✿ pencil
- ✿ rub-on words and pictures
- ✿ scissors
- ✿ 4" (10cm) square cardboard box
- ✿ straight pins
- ✿ tiny trinkets and keepsakes
- ✿ transparency image
- ✿ *optional*: chipboard elements

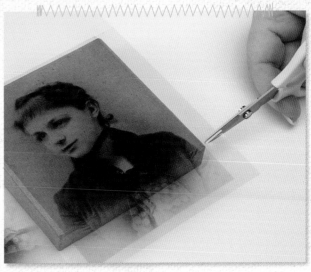

1 One of the hardest things in this project is waiting for the paint to dry. That said, start by painting the interior of your box with white paint. You'll be painting another coat in a bit so don't go overboard. When you've got everything covered, set it aside and let the first coat dry.

2 Lay your transparency image over the box top, and snip around all 4 corners. You will want to cut your image about ¹/₄" (6mm) inside your snips. This ensures that it will fit inside the box top, but still lay flat.

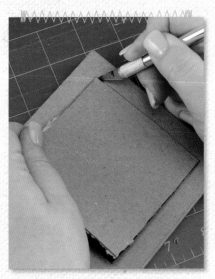

3 Draw a rough square on the front of your box top about a ¹/₂" (13mm) in from all 4 edges. Use a craft knife to cut this inner square out. Double check the size and orientation of your transparency by slipping it into the top of your box. You want the edges of your transparency to be very close to the inside edges of the box lid.

4 Squirt a little sky blue paint and a lot of white paint onto a paper plate. (This gives you a place to mix them together without making too much of a mess.) Dip your brush into the white paint and then into some light sky blue, and coat both the inside and outside of both halves of your box. Apply 2 coats to the inside and 1 to the outside in this manner with only a slight break in between coats.

5 Next, paint the outside of your box with a coat of sky blue paint, and a watered-down coat of white. (Add just a drop or 2 of water to your white paint for this coat.) Put on a third coat by quickly touching your brush into the sky blue, white and bright blue paints. This will give you a really cool streaky look that's just like a bright summer sky. Now you have to let everything sit again until it's dry to the touch.

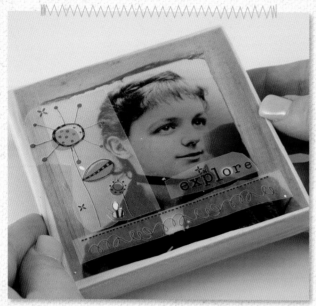

## notion

Try wrapping rub-on transfers around corners by bending the paper around the corner, and continuously rubbing the transfer until it's released onto both sides.

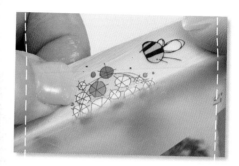

6 Cut out a bunch of rub-ons: things like flowers, bumble bees or whatever goes with your window box theme. Rub your transfers onto the sides of both box halves, and to the slick (front) side of your transparency. Test your rub-on placement by holding your transparency over the top of your cut box top periodically.

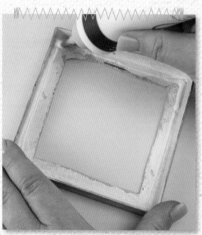

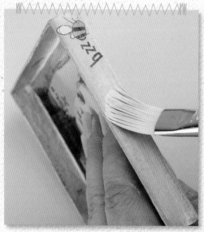

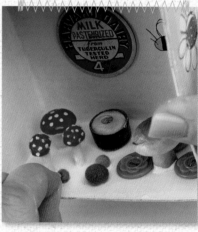

7 Lay a bead of craft glue around the inside of your box top, and carefully press your transparency image into it, front-side-down. You want to push from the inside out, making sure to push excess glue away from the visible part of your transparency image.

8 Dip a damp paintbrush into a bit of white craft paint and add a thin coat to the box. (Craft paint is thinner than artist paints and gives a whitewashed look to your rub-ons.) After you've given this final milky coat a chance to dry completely, add a couple more rub-ons over the top of the whitewashed ones.

9 Arrange your items inside the box to determine placement. It's much easier, and cleaner, to realize now that you don't like the way it looks than after you start using glue willy-nilly. Once you're happy with how everything looks, start sticking the trinkets down with adhesive dots or craft glue. If you prefer gel medium, knock yourself out.

## ☠ notion

To attach felt things with a skinny stalk, like this mushroom, it helps to perform a little trick using a straight pin. Poke a pin with a plastic head (so you have something to hold onto) into the center of the stalk, and gently wiggle it back and forth until you've pushed it in at least halfway. Then poke a hole through the bottom of your box with the same pin. Put that pin aside and stick a pin with a flat head up through the bottom of the box. Slide the felt object down onto the pin using the hole you poked a moment ago. Sneak a dab of glue under the bottom of your item when it's almost all the way down on the pin. This is just a little more insurance that it will stay stuck in your window, and not fall out to hide under a piece of your furniture. Attach a piece of duct tape over the pin heads to keep them from falling out.

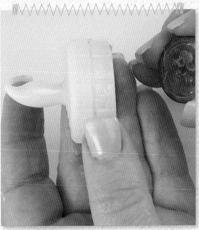

10 Turn your electric tea light on so you know which way the wick will be facing when in use. Most electric tea lights have a hollow space in the back. Fill in the space by placing adhesive dots on 1 side of a flat 1" (3cm) button, and sticking the button into the hollow space.

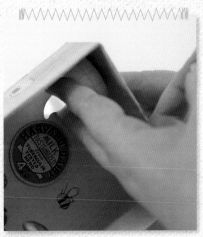

11 Add more adhesive dots to the other side of your button, and attach the tea light firmly onto 1 of the inside corners of your box.

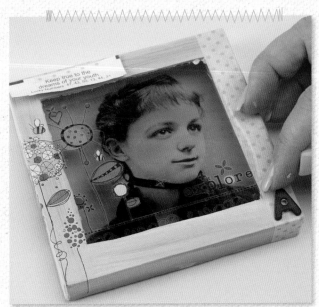

12 By this time your transparency image should be dry and firmly glued into your box top. Put the lid on your box and add a final touch of whimsy by using Japanese Washi tape and glue dots to attach things like chipboard letters and a fortune onto the front.

# Feather Your Nest Pillow

I'll apologize now, before I even get started, for infecting you with my pillow addiction. My obsession with zipper-bottomed pillowcases started last year when I took part in my first online pillow exchange. I found pillows to be a fantastic way to get started in quilting without the commitment of something so large as a blanket. I was hooked from the magical moment I pulled the finished case right-side-out through the zipper, and saw what I had accomplished! My pillow project is simple enough for someone with minimal sewing experience to complete without pulling their hair out, yet is complex enough to keep even an experienced sewer coming back for more. It's also very adaptable to pretty much any pillow design, so feel free to experiment away.

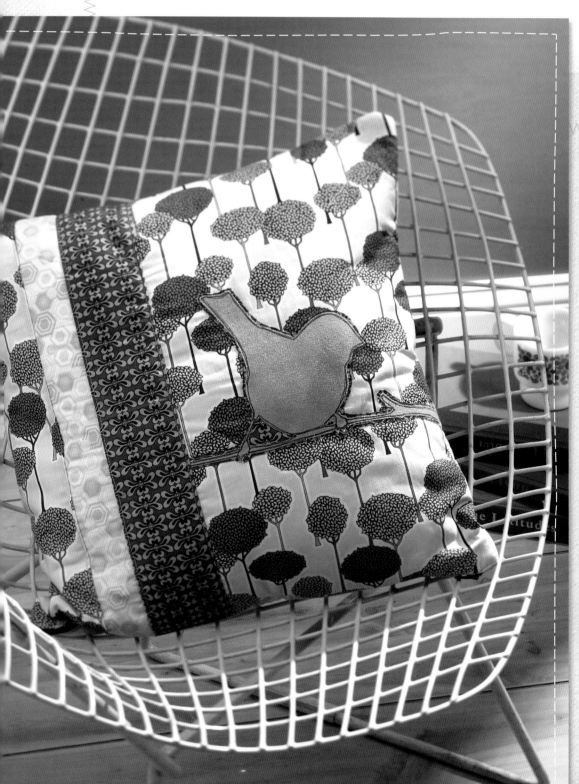

## materials

✿ fabric, ribbons and trims:

- 7" × 12" (18cm × 30cm) rectangle of dyed fabric (bird shape)

- 7" × 12" (18cm × 30cm) rectangle of dark contrasting fabric (bird shape outline)

- 2 fat quarters (46cm × 56cm) main print fabric (front and back panels; large tree print in this example)

- 3" × 20" (8cm × 51cm) complementary fabric (front center right strip; blue small print in this example)

- 2" × 20" (5cm × 51cm) contrasting fabric (front center left strip; yellow small print in this example)

- (2) 7" × 20" (18cm × 51cm) large secondary print rectangle: (back green strips)

- (2) 2½" × 2½" (6cm × 6cm) scraps (zipper tabs)

- (2) 7" × 12" (18cm × 30cm) rectangles of lightweight double-sided fusible webbing

- (2) 18½" (47cm) squares of low-loft batting

✿ Bird Silhouette Template (found on page 120)

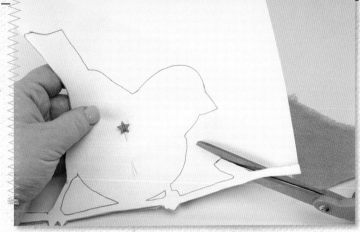

## before you begin

✿ From main print fabric, cut:

- 11½" × 20" (29cm × 51cm) strip (front right strip)

- 3½" × 20" (9cm × 51cm) strip (front left strip)

- 7" × 20" (18cm × 51cm) strip (back middle strip)

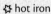

✿ hot iron

✿ paper

✿ 18" (46cm) pillow form

✿ pins

✿ rotary cutter

✿ ruled straightedge

✿ scissors

✿ self-healing cutting mat

✿ sewing machine

✿ small embroidery scissors

✿ thread

✿ 18" (46cm) zipper

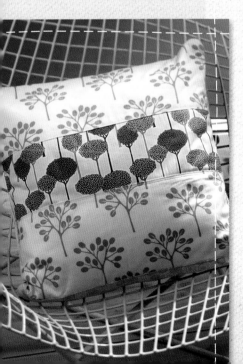

1 Scan and print or photocopy the Bird Silhouette Template (see page 120). Iron fusible webbing to the wrong sides of the 7" × 12" (18cm × 30cm) dyed fabric rectangle and the 7" × 12" (18cm × 30cm) dark contrasting rectangle. Once cool, pin the template to the right side of the dyed fabric rectangle, making sure all parts of the template have fabric beneath them. Cut out the bird silhouette and peel off the backing paper from this piece only. Fuse the bird onto the right side of the dark fabric rectangle with a hot iron.

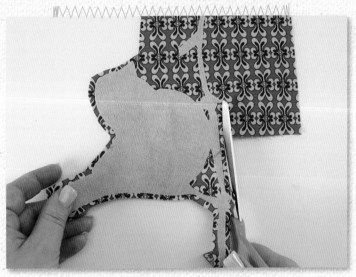

2 Cut out the bird shape again, trimming so that the dark fabric silhouette is slightly larger than the dyed silhouette. You should see 2 visible fabric layers. To cut out the tricky inside sections, simply fold the section in half and make a snip on the fold. Open the fold, insert your scissors in the small hole, and cut around the inside edge of the section. (It helps to use a small pair of pointed embroidery scissors to cut inside these small areas.)

 notion

If you can't sew straight to save your life (like me), don't worry. By stitching around the same path multiple times, you create a diversion from crooked stitches, and hide anywhere you've veered off course.

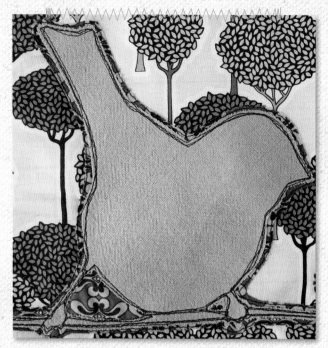

3 Remove the backing paper from the bird layers, and fuse the bird to the center of the 11½" × 20" (29cm × 51cm) main print fabric (front right strip). After it is cool, stitch just inside the edge of the top bird, going around 3 times. Next, sew just inside the edge of the bottom bird, going around once.

4 Now it's time to start piecing together your front panel, patchwork style. Place your complementary and contrasting front fabric strips right sides together, and straight stitch down 1 long side using a ¼" (6mm) seam allowance. Repeat to sew the 3½" × 20" (9cm × 51cm) main print fabric strip (front left strip) to the other long edge of your contrasting fabric. Open up your sewn panel. Working from the top side of the panel, press the inside edges of the 2 outer strips so they slightly overlap the center strip. This creates a faux over/under effect with the seam allowances.

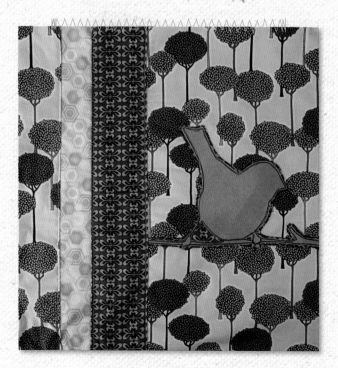

5 To finish sewing the front panel together, place the appliquéd bird panel right sides together with the pieced panel you made in Step 4, aligning the 20" (51cm) side. Before you stitch, make sure that when you open the seam, the bird will be on the right-hand side of the pieced strip set. Straight stitch down this long side to sew the bird panel to the strip set. Using the over/under technique from step 4, overlap the inside edge of the complementary fabric over the bird panel. Lastly, straight stitch 1 time down all the seams you overlapped onto the adjacent fabric to hold them in place.

6  To make the back of the pillowcase, sew together the three 7" × 20" (18cm × 51cm) fabric strips along the long edges with the main print fabric in the middle of the secondary print strips. Use the over/under pressing technique to create the same effect on the back of your pillow as you did the front. Straight stitch across the over/under flaps 3 times, just like you did on the top layer of the bird silhouette.

## notion

When doing this over/under iron-
ing technique, start in the middle
of the strip and work your way out.
This helps keep the seams straight.

(BATTING SIDE)

QUILTED SEAMS

7  Lay both of the completed front and back panels on top of a batting squares, right-sides-up. Use a rotary cutter, a self-healing cutting mat and straightedge to cut both panels down to 19" (48cm) squares. Sew back over your stitched over/under seams on the front and the back to hold the fabric and batting together, and to give your pillow a wonderful quilted look.

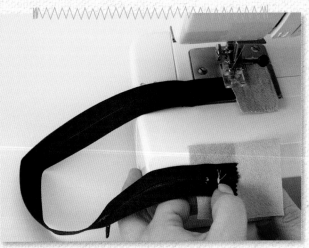

8  With a zero stitch length, zigzag both ends of the zipper shut, and move the zipper pull to the center of the zipper. Press each of the 2½" (6mm) fabric squares in half, wrong sides together, with a hot iron. Insert one end of the zipper into the fold of the tab. Using a wide, straight stitch, sew down the length of the fabric sandwiching the zipper inside as you go. Hold the zipper in place until you sew through it for the first time or it will try and escape. Repeat with the other end of the zipper. Don't be alarmed if your thread breaks. Simply re-thread, and keep on going. These tabs allow your zipper to lay flat without puckering out.

## notions

- Try using the fused scraps left over from cutting out the bird as the zipper tabs. The fusible webbing helps hold the zipper in place while you sew, but doesn't stick since you're not ironing them together.

- If you can't find an 18" (46cm) zipper, you can buy a longer one. Just cut it to the right length and follow Step 8 as you would for an 18" (46cm) zipper.

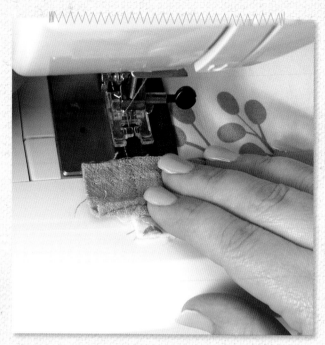

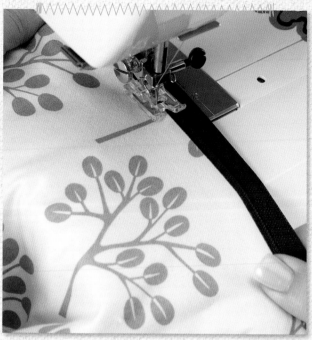

9 Lay the zipper on top of the back panel, right sides together, aligning the bottom edge of the zipper with the bottom edge of the panel. Sew twice down the length of the zipper, once along the outside edge of the zipper, and once next to the teeth.

10 Open the zipper away from the fabric, and fold the fabric so it is fairly close to the zipper teeth. Sew once more down the edge of the zipper from the top side to create a crisp seam and to hold the fabric down next to the zipper teeth.

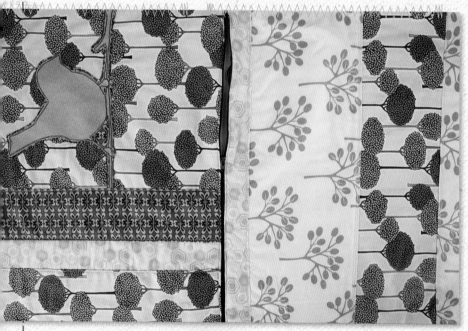

11 Repeat Steps 9 and 10 with the front panel of the pillow and the other side of the zipper. When you are finished, the pillow should look like a butterfly with the wings coming off of the zipper in the middle.

## notion

Start sewing the zipper onto the front and back panels with the zipper half open. When you get to the zipper pull, ease the pull under the presser foot, and continue on. This helps keep the sewing machine from jogging around the zipper pull as you sew around it. You can use a zipper foot to make this step easier, but it's not mandatory.

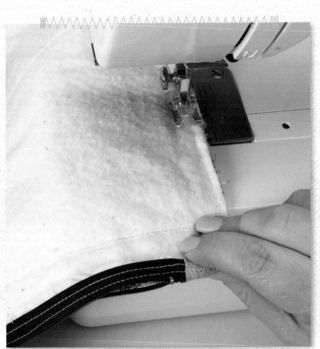

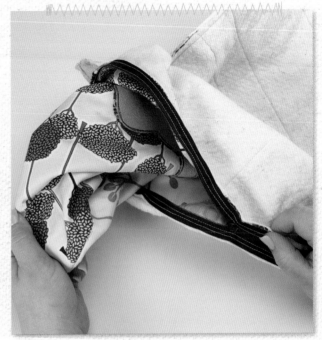

12 Unzip the zipper ³/₄ of the way, and fold the pillowcase in half, right sides together, matching up the edges. If you're worried about everything moving as you stitch, pin the 2 halves together. Starting at 1 end of the zipper, sew around all 3 edges of the pillowcase using a ¹/₂" (13mm) seam allowance. Turn and sew back to where you began. Smooth and adjust your edges as you sew to keep them from puckering.

13 Reach inside the open zipper and pull the pillowcase through. Use your finger to push out all 4 corners. Stuff the pillowcase with an 18" (46cm) pillow form, and zip closed. Find an open spot on your couch or give it to a friend in need of a smile.

 notion

Use a knitting needle, crochet hook or the
closed tip of a pair of scissors to help
turn the tough corners out. Be careful not
to poke so hard that you rip out the stitches
or break through the fabric, though!

# Jelly Picnic Blanket

I can't tell you how many times I wish I had thought of this patchwork-style picnic blanket when my children were little! I've designed this blanket so the top is soft cotton or linen, while the bottom is made of easy-to-clean oilcloths. The oilcloth keeps any dew or moisture from seeping up through the blanket and getting everyone's bum wet (which can make even the best of us cranky). I've made mine out of colors and prints that remind me of red and green apples, but whatever colors you choose, I hope this project inspires you to get outside with those you love and enjoy everything that Mother Nature has to offer.

## materials

- ✿ fabric:
  - large pieces of cotton and linen fabrics
  - large pieces of dyed fabric
  - large pieces of oilcloth prints
- ✿ hot iron
- ✿ removable double-stick tape
- ✿ sewing machine
- ✿ thread

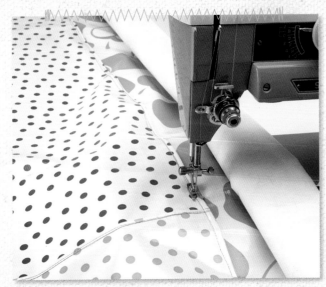

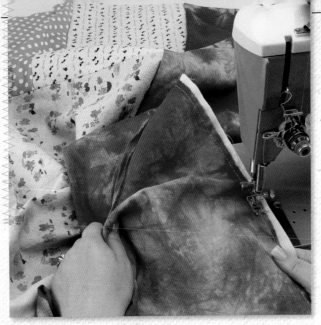

1 Using the *Patchwork Piecing* instructions (see page 24) and a little bit of patience, piece a large rectangle together out of printed oilcloth. The finished rectangle should measure slightly larger than your desired finished blanket size to allow for what you will lose in the seam allowances when you sew your sides together. Since you can't iron the seams flat (the oilcloth will melt), open up the seams, fold to one side, and topstitch over the seams several times to hold them open.

2 Piece your top rectangle in the same way out of any kind of fabric that's soft to the touch. Keep sewing sections of fabric together until you make a rectangle the same size as the patchwork oilcloth bottom. Press the seams open towards the darker fabric with a hot iron. Topstitch over the seams, like you did in Step 1, for added security and to make both sides look similar. This is a great time to use the decorative stitches on your machine!

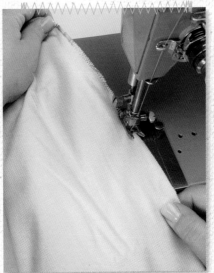

3 Place the top and bottom rectangles right sides together, and trim if necessary to ensure both pieces are the same size. Use removable double-stick tape to hold the 2 pieces together. Using a wide zigzag, stitch around all 4 sides, leaving about 24" (61cm) of one side open to turn the blanket through. Backstitch at the start and finish of the turning hole.

4 Turn the blanket right-side-out through the hole. Starting at a sewn portion of the edge (not at the hole), zigzag all the way around the edges until you come to the hole. Turn the raw edges of the hole under, and zigzag the hole closed. Continue zigzagging around the entire blanket. Sew around the perimeter of the blanket 2 or 3 times. (This flattens your seams since you can't iron the oilcloth. It also adds a decorative element to your picnic blanket, especially if you use a variegated or contrasting thread.)

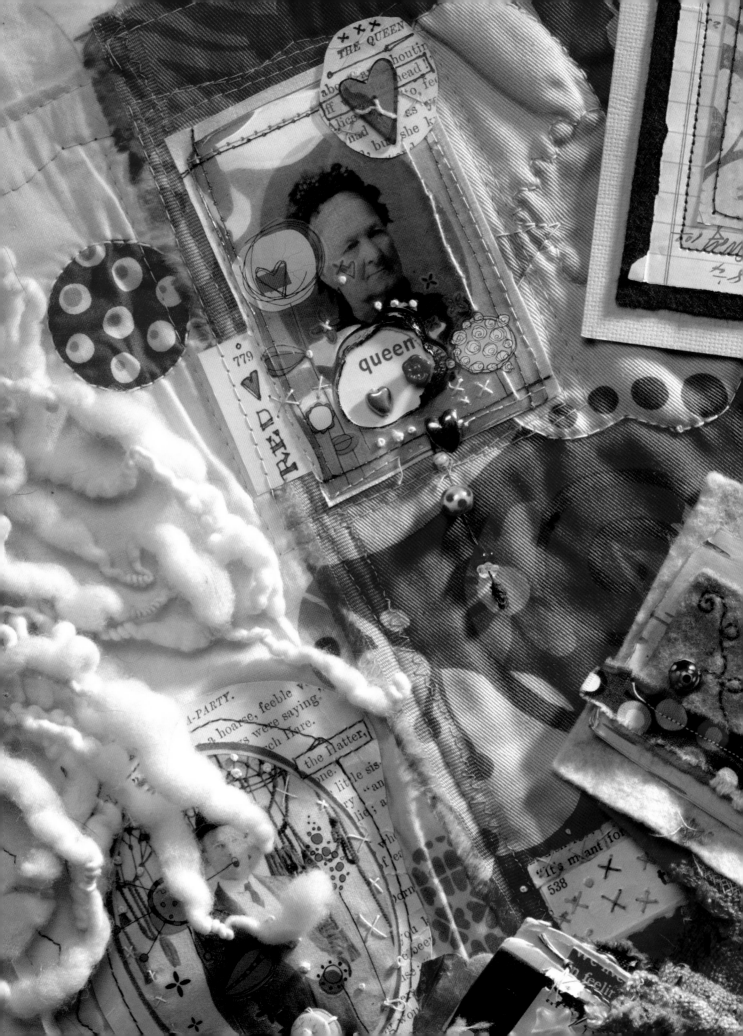

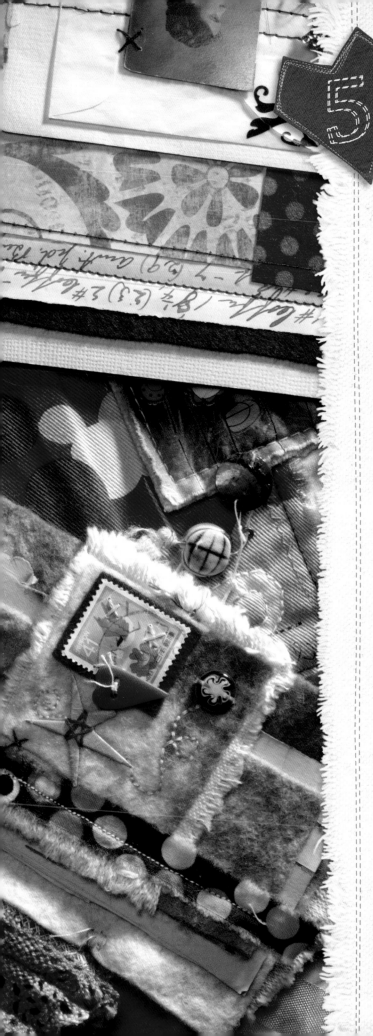

# now go make art!

The title of this last chapter is the way I close posts on my blog. It's my way of telling you it's time to get off the computer and go make something. The same goes double here; this book is meant to be a tool to help you on your way in the world of dye and fabric, but it's not meant to be a crutch or excuse not to create. Sometimes we get so caught up in the little details of our ideas that we accidentally cripple ourselves in the attempt of making them. It's important to really make things along with dreaming them up. The act of creating heals our mind, opens us up to new ideas, and can give us an amazing sense of accomplishment and peace. It also connects us to other creative people, sometimes in the most unexpected ways.

I'd like to share more of my favorite mixed and stitched pieces with you in the hope that it will ignite in you a desire to *Go Make Art!* I'll give you a peek around my studio to show you where I get most of my inspiration, and I'll even give you some of my favorite sketches to start you off down the long and winding road of stitching. My hope is that you'll make amazing things, and share them with anyone who'll look and listen.

**make**
verb

• to bring into being by forming, shaping, or altering material

• to lay out and construct

• to put together from components

excerpt, *Merriam-Webster's Collegiate Dictionary*, 10th ed., s.v. "Make."

# INSPIRATION GALLERY

### STARLIGHT JELLYFISH

Before I became an artist, I was positive I was going to be a marine biologist and save our oceans. I've left that dream behind to pursue art, but I'm still fascinated with sea creatures. This little jellyfish is hand-sewn using vintage quilt pieces from my friend, Lia. The Dresden-shaped pieces created a crown when I turned it right-side-out, and made me think of summer stars in the night sky. I stitched yarn and glass beads to the underbelly to create the wavering tentacles.

### TEARDROP FAIRY

Years ago when I was going through a rough patch, I found this Japanese proverb: "My skirt with tears is always wet; I have forgotten to forget." It really summed up my feelings at the time, and inspired me to create the *Teardrop Fairy*. She floats around in her tears on a charred transparency, and collects all my tears in her skirt so I can let them go.

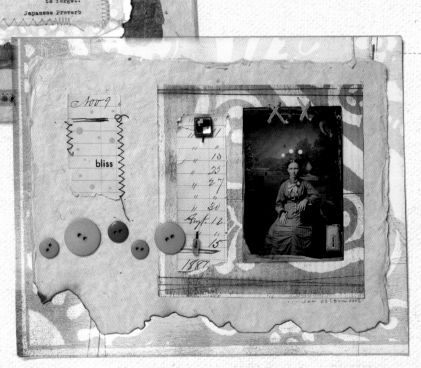

### SIMPLE BLISS

Like many artists, I've made a ton of art for others but have neglected the walls in my own home. This was the first collage piece I made for our new home, and it hangs in our downstairs bathroom. I had thought it was just background noise to my family, but within thirty minutes of taking it down to send in for this book, both my daughter and husband wanted to know where it had gone. I now know that it's a daily reminder for all four of us to keep it simple, and focus on that which brings us bliss.

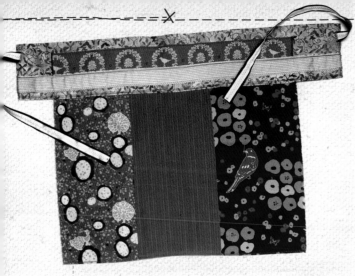

## SIMPLY FABULOUS APRON

This seductive little apron is made from fabric in various shades of violet and a snippet from one of my daughter's favorite pair of outgrown pants. I have two friends who called it fabulous from the start, and that description stuck with me when it came time to name it. One of the reasons it's so fabulous is that you only have to know how to stitch somewhat straight to complete it, and it looks marvelous as both a working apron or over jeans as you run around town getting things done. You might as well look fabulous as you run your errands, I always say!

## FARMKIDS SCRAPBOOK

On one of my first excursions into my town's antique district, I came upon a cigar box full of local vintage photos. It became clear they had belonged to a girl named Vicky, and were a collection of her classmates' pictures. My mind immediately began to whirl with the idea of creating a fabric scrapbook to hold them all, and the *Farmkids Scrapbook* was born. It took me almost five years to complete it, from first stitch to binding, but I wanted to make it as amazing as possible. I tried to recapture the colors and playfulness of my youth, and I stitched trinkets on each child's page to tell their individual story. I'm pretty confident that if I ever find Vicky, she'd be happy to know I took such loving care of her childhood memories!

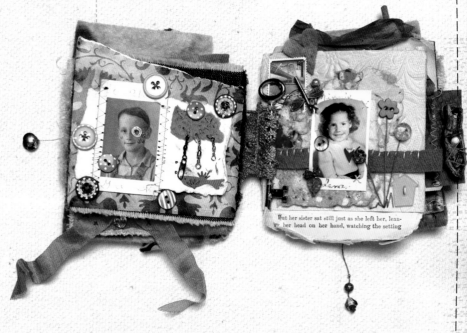

## RUNNING FROM THE RED QUEEN

This is the largest art quilt I've made to date. It's a stitched synopsis of *Alice in Wonderland*. I printed vintage images from my private collection onto muslin and overhead transparencies to represent all my favorite characters. My favorite is the one of Alice screaming that they're all just a pack of cards. I hand-quilted along the mushrooms in the fabric to give them a puffy look, and I used antique French language flash cards throughout the quilt to sum up Alice's adventures. Now RUN before the Red Queen gets you!

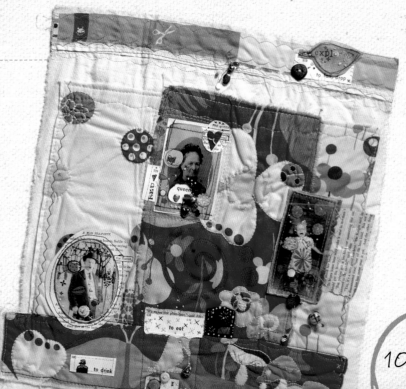

## LEFTOVERS ROLL-UP

I have a really hard time throwing away snippets of fabric that still seem useful, so I keep them all in a bag in my studio. I started making these art supply roll-ups as a way to use them up. It's made of little fabric scraps sewn side by side, and then stitched down on a larger piece of fabric. I wrote "wear striped socks" on my computer, and then printed it on iron-on transfer paper. It's a reminder to keep the lighter side of life in mind on those difficult days. The linen ant fabric on the outside helps remind me to work like an ant when in comes to deadlines—something I'm not always so good at.

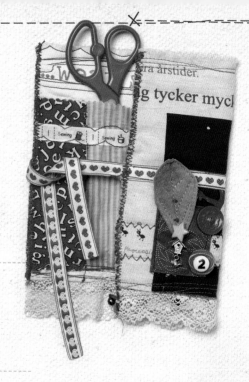

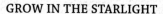

## 7 DEADLY SINS

I made this scrumptious book when I was first falling in love with textures. The 7 Deadly Sins have long been an inspiration for artists and I'm no exception. I had just started burning little holes in my transparencies to let objects peek through, and had an amazing collection of luscious bits of felt. My husband helped me by turning wood trim into weathered, driftwood-inspired page spacers. When you hold this in your hands you can feel the weight of the love that went into making it. I make my art to be touched, and in this book there are many different textures for your fingertips to enjoy!

## GROW IN THE STARLIGHT

Each summer when my family drives down to the Tennessee mountains, I take a little bit of handiwork with me. I'm always so inspired by the mountains, forests, rivers and waterfalls there. One of the things I love most about Tennessee is the pitchblack darkness that falls each night, and how the stars seem to explode into the night sky. I think that sometimes we only need starlight to grow. I love how the textures and colors seem to both grow upward toward the stars, and melt down into the soil. I sewed the heart button onto the waxy root to represent how we all need love to grow regardless of the dark or light we're living in. I hope you find that love and learn to grow in the starlight.

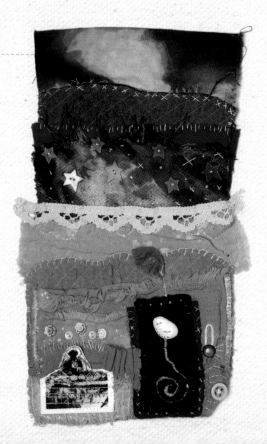

## THE WITCHING HOUR

I love Halloween almost as much as my birthday, and every year my family dresses up to pass out candy. I am so inspired by the dramatic colors, the whimsical costumes, the thought of being scared, and especially how important this day is to small children. Sometimes our children suffer through photographs for us, but their true feelings are always apparent. This little one looks as if daggers might fly out of her eyes any moment! From the dirty cracks to the shiny brocade to the sparkling glitter and the matte thread, this paper quilt is Halloween eye candy galore!

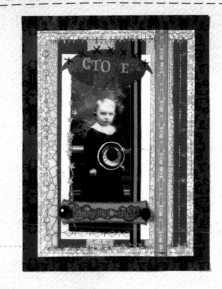

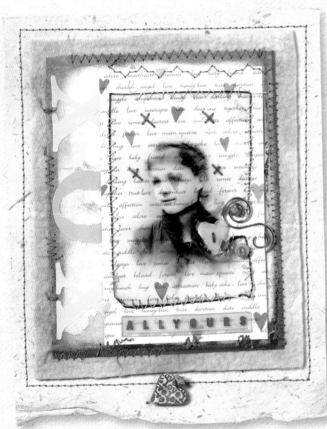

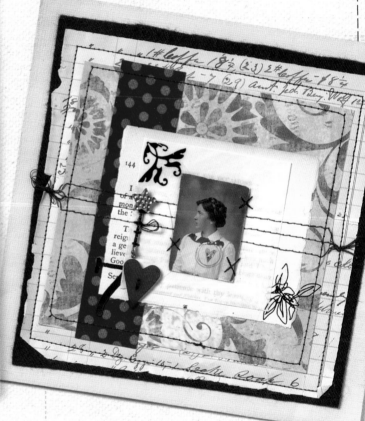

## ALL YOURS

Next to Halloween, my favorite holiday is Valentine's Day. I love bright and cheery colors, hearts as far as the eye can see, and giving the gift of love to those around me. Every year I create a new batch of special, handmade valentines and envelopes. This is the first one I ever made for my husband, Larry, and it's displayed year round on my pie safe. I used muted colors with a tinted, singed transparency image to portray how fragile love can be. If you look really carefully, you'll see that I also got a circle of paper to hover over the image's left eye, reminiscent of the Queen of Hearts. Sneaking little details like this into my creations really allows a piece to speak to me.

## LONGING

Let me just get it out there that I simply adore this piece. It combines all of my favorites into a single piece of simple art. When I found this vintage photograph, I remember thinking about how the woman seemed to be looking for something or someone off in the distance. It stirred up feelings of longing within me, and brought to mind the longing I feel when I am apart from my family. Even though the name of this piece seems melancholy, it's really not—sometimes we long for things so desperately that we make them happen.

**THE SECRET KEEPER**

Rather than just write something in black and white, I choose to pour all my techniques and project ideas into this handmade paper journal. Over the course of a year, I made tiny pieces of original art for many of the pages, and drew the rest in ink and colored pencil. The result is a journal that holds the secrets to everything artistic banging around in my noggin. It's a wonderful way to keep track of all your technique secrets and to flesh out ideas that you think just might work. What a wonderful way to share your secrets with those you trust and love!

**ALICE WONDERED**

This little book was one of the very first I made from start to finish all by myself. Looking through it's pages, I remember the excitement I felt using transparencies, and how new the whole world of mixed media was to me. My goal for the book was to show Alice through the ages, not just her famous stint in Wonderland; she was a young child before, and grew to be an old woman after. I imagined her at the end of her life wondering if any of it had really happened or if it had all, in fact, only been a bizarre bunch of dreams. I took all my favorite characters, and turned them into pages throughout the book. Interspersed are snippets of Alice's life that help to tell her story.

**HAPPY**

In the past I used my sewing machine to sew everything except buttons, beads and other round or curved elements together. But when I began making this piece in the mountains of Tennessee, I didn't have my sewing machine with me, forcing me to hand-sew everything. I found this an oddly relaxing process, and my desire to embroider was stoked into full flame. The cloud, made out of yarn, is a great example of using embroidery to attach elements; each billowy part was sewn down using carefully placed stitches. I also started to really focus on the fabrics I use as a way to help tell my story, and chose ones that look like soil, a neighborhood, and a swirling summer sky to fill in the rest of this lady's tale.

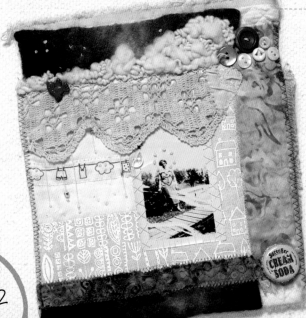

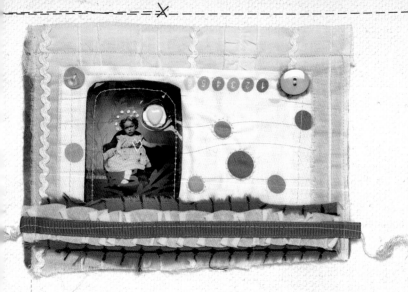

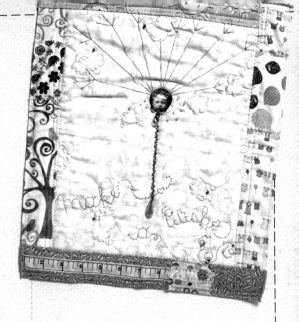

## AM I BLUE?

This is a great example of a raw story quilt that's meant to hang on a dowel or iron rod. I lightly singed the edges of the transparency and then sewed it onto my fabric. The quilt has an amazing felt backing, but I left the edges raw to help convey this little girl's ennui-induced blueness. She sits all alone thinking miserable thoughts. Terrible, I know, but that was where I was emotionally when I made this piece. I remember I had just gotten terrible medical news and was feeling very down in the dumps. Those feelings translated themselves into this little story quilt that looks as raw as I felt at the time.

## QUILTING THE PAST

I have an obsession with tiny vintage photos, specifically old photo booth ones. I'm always stymied about what to do with them and have the hardest time using them in anything but special projects. I used seven of them in this book as the focal point of each quilted page, and I created a little story about each one. My favorite page shows a lady under an umbrella; I decided that her parasol was to keep snowflakes off her face, so I added a slew of French knots to represent the falling snowflakes. The dichotomy between the bright colors and soft fabrics is a great way to add visual texture. I also used complementary and contrasting colors to play up the visual interest without having to use a million fabrics.

## MAKE A WISH

This was my first attempt at a quilt with a fabric edge around the outside. I printed a picture of a surly boy onto a transparency, and then singed it with a lighter to make it curl up on itself. The downy tufts of the boy's wish are sewn with silver thread and run through eyelets to anchor them down to the wind. I quilted the body with a decorative stitch, and then dangled an antique glass charm from the bottom to keep the wish upright in the breeze. You can never have enough wishes; this quilt reminds me to close my eyes and make one.

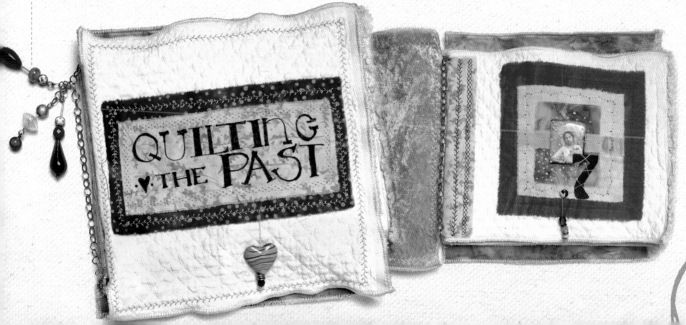

# A PEEK INSIDE MY MESSY NEST

I know what you're thinking: messy nest, yeah right! Well, let me tell you that it took a whole week to get my studio looking this fabulous; it looked like the *Wreck of the Hesperus* the day before these photos were taken! My studio is a sacred place, but more often than not it looks like my brain feels—a disaster zone. This is the place where I'm free to combine my love of antiques with the fresh and modern. Many of the pieces in my studio came from my grandmothers, both of whom always encouraged me to be myself. It brings me such peace to know that a small bit of them is with me as I create. From the tea cart where I keep my found objects to the curio cabinet that holds dolls and teddies, every little bit of me is represented here in some way.

Even if you only have a linen closet to create in, I encourage you to make it completely yours. Fill it full of inspiring art, found objects and anything that inspires you. Find fun and unusual items, like vintage kitchen items, to contain your supplies and put a smile on your face. Most of all, make it a place that stops your heart a bit every time you walk in the door, and that makes you feel safe to create your way!

*This is where the magic happens. Everything is at my fingertips, and there is inspiration everywhere I look.*
(Photo courtesy of Jen Osborn)

*I just love this curio cabinet—I keep it full of childhood memories!*

(Photo courtesy of Jen Osborn)

## 10 reasons I love my studio:

✿ The walls are the color of the Michigan woods in spring.

✿ My boys put my workbench together, hung my ribbons and built my inspiration shelf.

✿ Every article I've ever published is on the floor under the bedside table.

✿ My teddy watches over me from the curio cabinet by the door.

✿ There's room for my daughter, Jules, to come in and play with me at my sewing table.

✿ The sun shines in all day long, filling my studio with light and smiles.

✿ There's lots of shelf space to hold my fabric collection.

✿ My favorite books are just an arm's length away at all times.

✿ I'm constantly inspired by my favorite pieces of furniture and antiques.

✿ The middle of my art room is perfect for twirls, dancing and singing, or rolling on the floor in laughter.

*Tucked away on this shelf is a cigar box where I keep my collection of vintage gem photos.*

(Photo courtesy of Jen Osborn)

*I hang my aprons right inside the door to my studio. As I walk in, I put one on and I'm ready to create.*

(Photo courtesy of Jen Osborn)

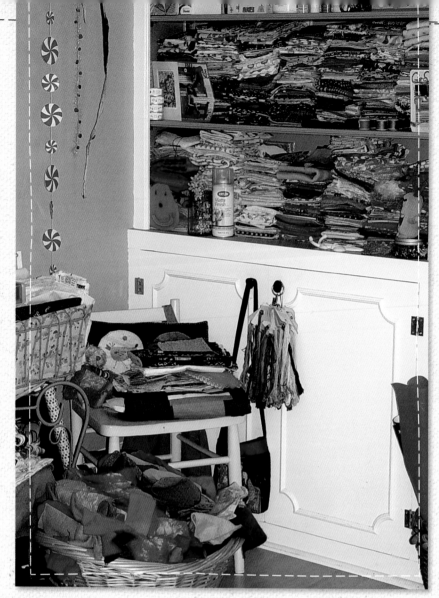

*I try to keep my fabric organized by color, but sometimes I have too much and it spills over onto my furniture.* (Photo courtesy of Jen Osborn)

# 10 favorite storage and organizational tricks

✿ Old type- or apothecary drawers are great for storing small found objects.

✿ Utilize wall space with vintage hooks and curtain rods to hold jewelry, hats and aprons.

✿ Furniture with drawers or cupboards is a must—you can hide your mess inside them.

✿ Metal planters are great for storing fabric or books in a way that lets you find what you're looking for in the blink of an eye.

✿ Flower pots, baskets and buckets are wonderful for punches, ribbons and buttons.

✿ Tea light holders or soy sauce cups hold small amounts of beads for a project.

✿ Antique bottles are great to hold paint-brushes or buttons.

✿ Keep your journals in a bag ready to grab and go as you walk out to run errands.

✿ Canning jars are a must—they hold just about everything and can be found easily in any mess.

✿ Use a dowel and curtain rod clamps to display all your ribbons where you can see them for instant inspiration.

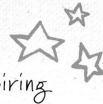

# 10 special and inspiring items in my studio:

✿ a vintage Remington typewriter where I type up quotes, sayings and story snippets for my art

✿ my Grandma Lois's antique tea cart where I keep my brushes and found objects

✿ my Grandma Bro's curio cabinet where I hide treasures from my childhood

✿ the cherry shelf above my workbench that my husband carved to look like driftwood

✿ bottles and jars filled with Christmas lights, buttons, beads and metal findings

✿ my 1950's Singer slant-arm sewing machine

✿ vintage gem photo albums squirreled away all around my studio

✿ a colorful rod full of ribbon spools

✿ books from my childhood where I find sayings for my art

✿ antique ledgers full of old grocery lists and customers

✳ now go make art!

*This is my quiet corner. It's a place I can read, brainstorm or stitch in peace.* (Photo courtesy of Jen Osborn)

# TEMPLATES

For accurate results, make sure you photocopy and enlarge
the patterns and templates to the indicated size before using.

APPLE OUTSIDE TEMPLATE
Enlarge to 200%

APPLE CORE TEMPLATE
Enlarge to 200%

HOUSE TEMPLATE
Reproduce at 100%

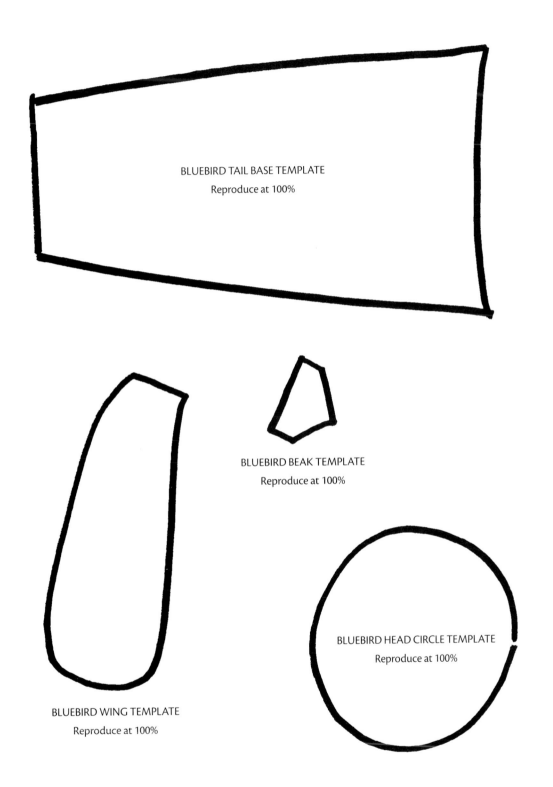

BLUEBIRD TAIL BASE TEMPLATE
Reproduce at 100%

BLUEBIRD BEAK TEMPLATE
Reproduce at 100%

BLUEBIRD HEAD CIRCLE TEMPLATE
Reproduce at 100%

BLUEBIRD WING TEMPLATE
Reproduce at 100%

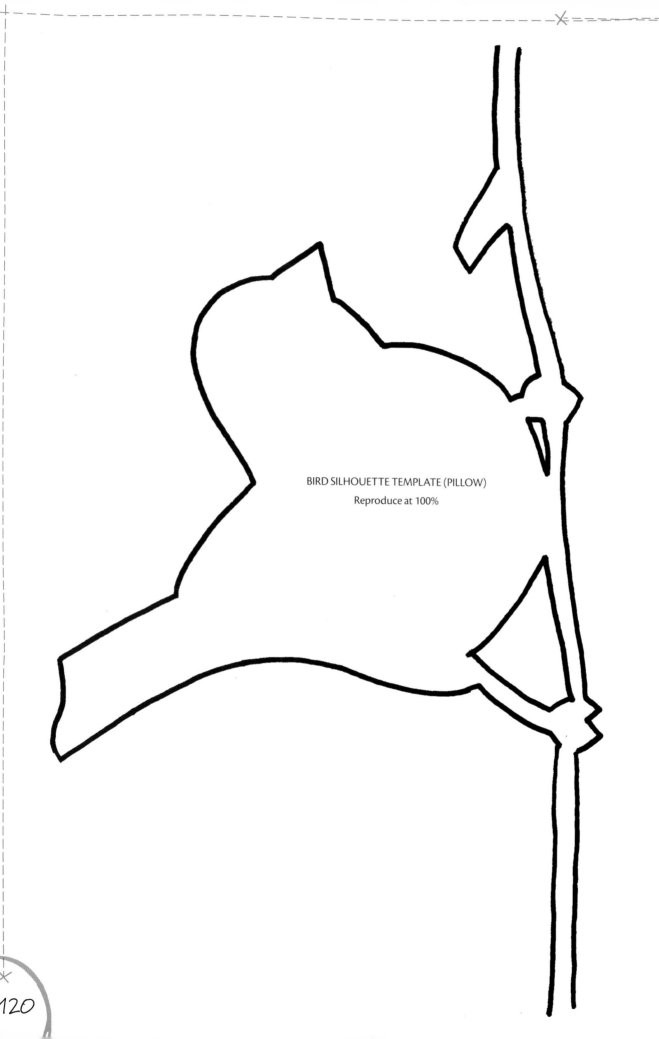

BIRD SILHOUETTE TEMPLATE (PILLOW)

Reproduce at 100%

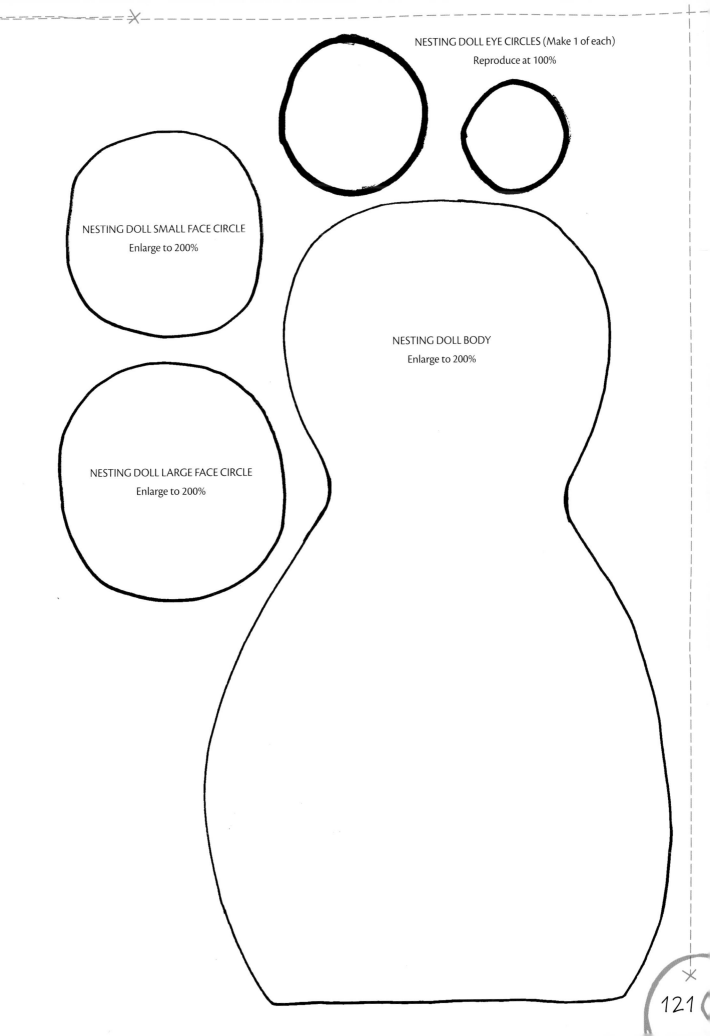

NESTING DOLL EYE CIRCLES (Make 1 of each)

Reproduce at 100%

NESTING DOLL SMALL FACE CIRCLE

Enlarge to 200%

NESTING DOLL BODY

Enlarge to 200%

NESTING DOLL LARGE FACE CIRCLE

Enlarge to 200%

# SKETCHY-STITCHING SKETCHES!

Here are some of my quirky illustrations for you to embroider on your dyed materials.
Just use transfer paper and pencil to copy the image onto fabric, and then stitch along the outline.
Enlarge or shrink the images to fill any space.

fox on a cold WINTER day

★─a bright ORANGE✦

HOOT

★─a wise old owl on→ a starry summer NIGHT

WINTER

Stillness
.QUIET.

ragdoll of love

unlock your HEART

bursting

tweet

be a songbird

turn that frown

UPSIDE down

CHIRP

caged BIRD sings

i know WHY the

123

~ARGH!

Dance to your own Quiet song

mute

mute

~dare to change your act

GROW

reach out + sprout

OH TEDDY!

Grr

~you are 1 silly bear

# MY FAVORITE THINGS

With all the places popping up online to cash in on the mixed-media craze, it's like going on a treasure hunt to find quality products that are worth the money. Here is a list of products I not only use, but love, as well as a list of art websites that help keep me inspired and motivated:

PRODUCTS

**Clorox**
www.clorox.com
*bleach pens*

**Colorbok**
www.colorbok.com
*Heidi Grace scrapbook supplies*

**Fabri-Quilt Fabrics, Inc.**
www.fabri-quilt.com
*Fabrics, including "Save Our Planet" print*

**Fiskars**
www.fiskars.com
*fabric scissors*

**Jaquard**
www.jacquardproducts.com
*iDye, Tee Juice fabric markers*

**Making Memories**
www.makingmemories.com
*Instant Setter (eyelets)*

**Moleskine**
www.moleskine.com
*Cahier and Volant notebooks*

**MT Masking Tape**
www.masking-tape.jp/en
*decorative tape*

**OLFA**
www.olfa.com
*rotary cutters, mats and rulers*

**Rit Dye**
www.ritdye.com
*dyes*

**Spoonflower**
www.spoonflower.com
*custom designed fabrics*

**Uni-ball**
www.uniball-na.com
*Signo gel pens*

**Valdani, Inc.**
www.valdani.com
*hand-dyed variegated threads*

ONLINE COMMUNITIES

**CrescenDOH!**
www.crescendoh.com

**Brave Girls Club**
www.bravegirlsclub.com

**North Light Craft**
www.CreateMixedMedia.com

ART COACHES

**Alyson Stanfield**
www.artbizcoach.com

**Laura Bray**
www.katydid-designs.com

# INDEX

I grew up in a house where crafting was an every day occurrence, and I just assumed that everyone else did the same. It wasn't until I was in school that I realized how rare and special it was to make art. The up-side to this is that I always had something to do, and my writing and drawing talents took off as a result. The downside is that art became such background noise that I never pursued it as something to learn and expand upon. Eventually, I turned away from writing and began to pursue math and science voraciously! (I haven't taken a writing class since 10th grade, and I have to really laugh that I now make my living in this field.) I went on to become a biology major in college; I still have a deep love of science, and you will see me sneak in little references to it in my art all the time.

I remember making art as a child and young adult, but when boys came along, all my art supplies were put away. I met my husband, Larry, one starry night at the Blue Sky Drive-In, and as silly as it sounds, I instantly knew that we were soul mates. Almost 25 years later we've hardly spent a day apart.

I started crafting again when my kids were little, but it was always things like homemade playdough, kleenex guitars or maracas filled with beans—not anything like what I do today. But as luck would have it, one day my eyes fell upon an issue of *Somerset Studio*. It completely caught my attention, and as I scanned the pages some little spark inside of me reignited; I instantly knew I needed to start making art again.

Part of what helped fuel my newfound love of art was moving to a small farming community, and being pretty isolated at first. Thank goodness for the internet and online art groups! My first experiences online revolved around mail art, and oh how I love it! I've made friends all over the world thanks to sending letters and art. There's something special about receiving a real letter and piece of art in your mailbox in this age of technology and digital communication.

Creating can sometimes be a lonely experience, but having art friends all around the world has made me feel not so alone when I'm in my studio by myself. I know that somewhere on the globe one of my "art girls" is in her studio just like me, and even though we're oceans apart we are connected through our art!

## visit me at:

- mixedandstitched.blogspot.com
- www.themessynest.com
- blog.themessynest.com
- identityseven.typepad.com/365_days_of_40

# Discover more
## mixed and stitched inspiration with these titles:

### LAYERED, TATTERED & STITCHED
*Ruth Rae*

Learn how to create fabric art with incredible depth and meaning in *Layered, Tattered & Stitched*. Mixed-media artist Ruth Rae expands your creativity as she shows you how to singe, tear, stain, layer and stitch fabric and paper for amazing texture and visual interest. Explore both traditional and atypical sewing techniques combined with collage, beading and photo transfers to make gifts, wall hangings, accessories and more.

*paperback • 128 page*

### SHARING STITCHES
*Chrissie Grace*

Join Chrissie Grace and 15 talented artists as they exchange fabrics, collaborate on an art quilt and swap plenty of inspiration on the pages of *Sharing Stitches*. Stitch by stitch, Chrissie shows you how to create colorful and eclectic projects as unique as the group that sews them, including a patchwork pullover, a lace-embellished headband, a large-scale collaborative quilt and a round robin journal. Break out your sewing machine, round up your friends and start sewing!

*paperback • 144 pages*

### JOURNAL SPILLING
*Diana Trout*

*Journal Spilling* is all about incorporating journaling and art-making into daily life, all the while encouraging a carefree, non-judgmental approach. In addition to step-by-step instruction for 25 media techniques (watercolor, resist, ink, transfers and more!), you will be guided through exercises to help with writing. Learn to let go of complete control and trust the journaling process!

*paperback • 128 pages*

These and other fine North Light Books titles are available from your local craft retailer, bookstore, online supplier, or visit our website at www.mycraftivitystore.com

www.CreateMixedMedia.com
The online community for mixed-media artists

Techniques • projects • e-books
artist profiles • book reviews

For inspiration delivered to your inbox and artists' giveaways, sign up for our FREE e-mail newsletter.